WARREN ROHRER

WARREN ROHRER

PAINTINGS 1972-93

Susan Rosenberg

Philadelphia Museum of Art

Front cover: *Two Elements,* 1984 (pl. 17); back cover: *Corn Stubble,* 1973 (pl. 2)

This book is published on the occasion of the exhibition
Warren Rohrer: Paintings 1972–93 at the Philadelphia Museum
of Art from June 22 to August 17, 2003

The exhibition and catalogue were supported by The Dietrich
Foundation, the Kathleen C. and John J. F. Sherrerd Endowment
for Exhibitions, The Pew Charitable Trusts, The Judith Rothschild
Foundation, the Robert Montgomery Scott Endowment for
Exhibitions, the Locks Foundation, Mr. and Mrs. Berton E. Korman,
Mr. and Mrs. B. Herbert Lee, Francey and Bayard Storey, and
other generous individuals.

Produced by the Department of Publishing
Philadelphia Museum of Art
2525 Pennsylvania Avenue, Philadelphia, PA 19130 U.S.A.
www.philamuseum.org

Edited by Jane Watkins
Designed by Andrea Hemmann/GHI Design
Production managed by Richard Bonk
Map (p. 60) by David Noble
Printed in Germany by Cantz

Library of Congress Cataloging-in-Publication Data

Rosenberg, Susan, 1963-
Warren Rohrer: Paintings 1972-93 / by Susan Rosenberg.
p. cm.
Published on the occasion of the exhibition at the Philadelphia Museum of Art
from June 22 to August 17, 2003.
Includes bibliographical references.
ISBN 0-87633-166-5
1. Rohrer, Warren–Exhibitions. I. Rohrer, Warren. II. Philadelphia Museum of Art. III. Title.

ND237.R7144 A4 2003
759.13–dc21 2002193055

Contents

Lenders to the Exhibition

The Bohen Foundation
The Dechert Collection
Daniel W. Dietrich II
Duane, Morris, LLP
Helen W. Drutt English
Wilder Green
Robert and Ana Greene
Mr. and Mrs. Paul T. Gruenberg
Ted and Kathy Hicks
Mr. and Mrs. Vernon Hill
Mr. and Mrs. Berton E. Korman
Jane and Leonard Korman
Mr. and Mrs. B. Herbert Lee
The McCrae Collection
Philadelphia Museum of Art
The Rohrer Family
Robert Montgomery Scott
Mari and Peter Shaw
Mr. and Mrs. Jonathan Solomon
Doris Staffel
Bayard and Frances Storey
Ana and Rodman Thompson
Private collections (three)

Preface

It is a rare honor and an enormous pleasure for the Museum to present the work of an artist who has been a dear friend as well as a greatly admired painter. Warren Rohrer, who died at the age of sixty-seven in 1995, was among those individuals who comprise one of the most intensely gratifying constituencies of a large art museum: the artists who use the collection as if it were their own backyard, whether leisurely roaming the galleries of many centuries and cultures, stopping in for the quick fix of a favorite painting, sharing their perceptions with successive generations of students, or unknowingly serving as a curator's conscience as he or she plans an installation. The spirit that these artists bring to this Museum, both in person and in the works they produce, enlivens all the works of art in our collections in ways their makers never could have envisaged. They personify the Museum's role as a place for the connection of past, present, and future.

Rohrer's presence in Philadelphia is one that will not be forgotten. The apparent quiet of his paintings belies their compelling power and their lasting hold on the imagination. Their complexity continues to grow more beguiling as time goes on, and the particularity of their vision all the more remarkable. Rohrer's inspiration also is felt in the work of many others whose work superficially has no resemblance to his own. He extended a distinguished Philadelphia tradition in his more than thirty years of teaching in the public schools, the studio classes held at this Museum, the Pennsylvania Academy of the Fine Arts, or the Philadelphia College of Art (now University of the Arts). Like the best of art teachers (one thinks of Josef Albers), the strictly defined parameters of his own mature vision bore inverse relation to the experimentation he encouraged in those starting out.

Rohrer's articulate and passionate embrace of his vocation inspired a wide circle of friends and supporters over the years, many of whom have extended great generosity in their participation in the development of this exhibition and catalogue. We echo Susan Rosenberg's heartfelt gratitude for the invaluable contributions of Jane Rohrer, who spent close to half a century sharing Warren's life and work and who remains a dedicated conservator and communicator of his vision, and of Daniel W. Dietrich II, who as both a friend and collector came to understand Warren's painting in a uniquely profound way. We also extend warmest thanks to Sueyun Locks, Francey Storey, and Frederick R. McBrien III for their commitment to the exhibition in offering information and recollections and providing greatly appreciated assistance. The exhibition and catalogue received generous and indispensable financial support from The Dietrich Foundation, the Kathleen C. and John J. F. Sherrerd Endowment for Exhibitions, The Pew Charitable Trusts, The Judith Rothschild Foundation, the Robert Montgomery Scott Endowment for Exhibitions, the Locks Foundation, Mr. and Mrs. Berton E. Korman, Mr. and Mrs. B. Herbert Lee, Francey and Bayard Storey, and other generous individuals. We thank Iva Gueorguieva for her dedicated work on the chronology of the artist and myriad administrative and research matters. Finally, we are delighted to express our gratitude to Susan Rosenberg, Assistant Curator of Modern and Contemporary Art, for the sensitivity and devotion she brought to this exploration and presentation of Rohrer's work.

Anne d'Harnoncourt, *The George D. Widener Director*
Ann Temkin, *The Muriel and Philip Berman Curator of Modern and Contemporary Art*

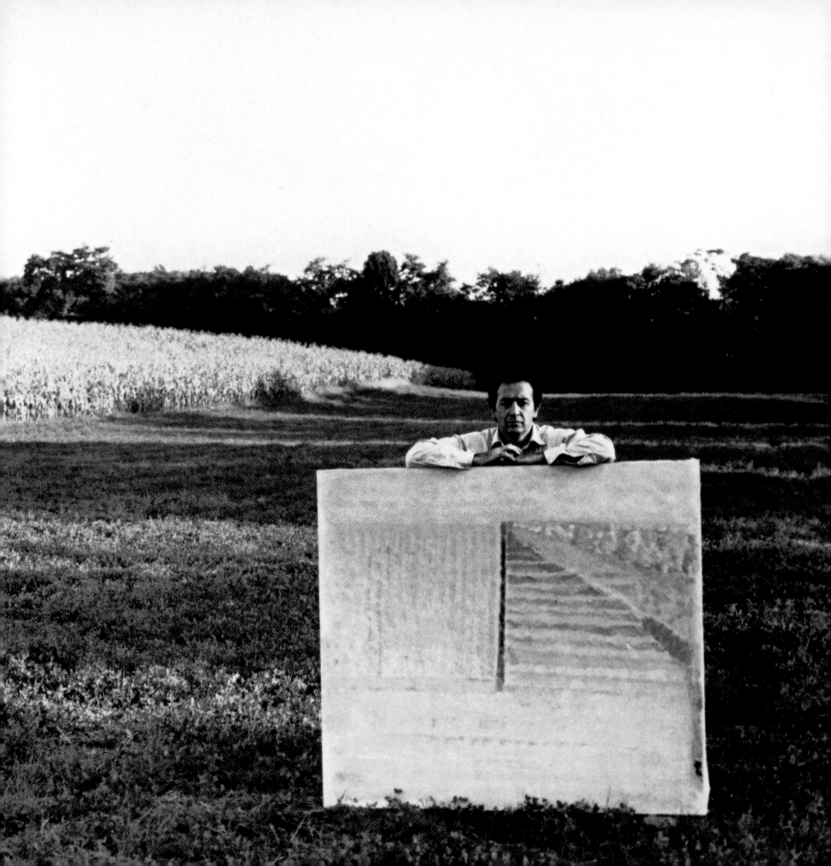

Warren Rohrer

SUSAN ROSENBERG

Warren Rohrer stands in a landscape holding one of his paintings on an announcement for a December 1971 exhibition at the Makler Gallery in Philadelphia (fig. 1). In a field not far from his home in Christiana, Pennsylvania, the artist looks out at the viewer from a landscape that is both present and past—the place where he lived at the time and a landscape replete with memories of his youth in Lancaster County, Pennsylvania. The painting, comprised of a puzzle-like arrangement of interlocking shapes, presents the differentiated patterns of farmed fields as a kind of primitive map or flag. The image declares a sense of belonging, purposefully celebrating the inseparable connections between artist, painting, and place.

Created at a time when artists like Robert Smithson (fig. 2) and Dennis Oppenheim (fig. 3) were making art out of the land and taking photographs of the results, Rohrer's announcement was a painter's retort to contemporary art movements that rejected as outmoded the traditional terms of paint on canvas, which Rohrer wholeheartedly embraced—very much against the current of his time. Rohrer remained in the rural community of Lancaster County despite an art world that was decidedly urban and increasingly international. The photograph encapsulates Rohrer's choice of life as a painter over the life of a farmer ordained by his family. Establishing his private province of painting in the landscape of his beginnings, he discovered in his unique heritage the basis for inventing his artistic originality in terms both modernist and regionally distinct.

The story of Rohrer's early life, growing up in an insular agrarian Mennonite community, is the stuff of myth. Born in Smoketown, Pennsylvania, in 1927, Warren Rohrer was

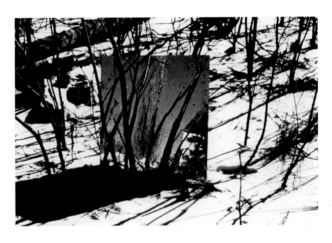

Fig. 2. Robert Smithson (American, 1938–1973), *Point E, East Circle Drive/Route 34* from *Ithaca Mirror Trail, Ithaca, New York*, 1969.

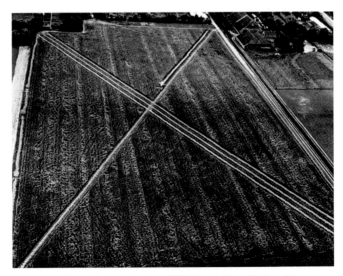

Fig. 3. Dennis Oppenheim (American, born 1938), *Cancelled Crop*, Finisterwolde, Holland, 1969. Wheatfield and harvester, 462 x 801 feet (140.8 x 244.1 m).

Fig. 1. Warren Rohrer with his painting *Farm: August, 1971*, an announcement for an exhibition of his work at the Makler Gallery, Philadelphia, in 1971.

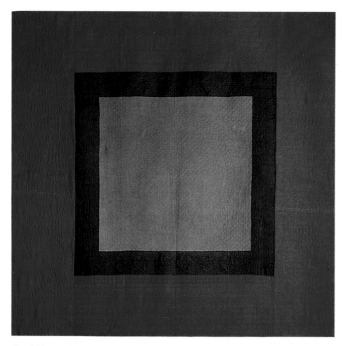

Fig. 4. Maker unknown, *Center Square Quilt*, c. 1900. Wool and cotton pieced work, 80 3/4 x 80 3/4 inches (205.1 x 205.1 cm). Philadelphia Museum of Art. Gift of Mr. and Mrs. Warren Rohrer, 1982 (1982-136-1).

the eldest child of Edna Eby and Israel Rohrer. A ninth-generation American, he was raised by austerely religious Lancaster Mennonite farmers, whose families had worked the land nearly continuously since the eighteenth century. The Ebys had come to the New World about 1715 under the auspices of William Penn, fleeing religious persecution in Europe. They were part of a larger wave of Mennonite immigrants who had left Switzerland and settled first in Germantown before fanning west into an area north of the Conestoga River in Lancaster County. The Rohrer family arrived in the 1730s. To the New World the Mennonites brought remarkable skills as farmers known for their ability to make fallow land richly fertile. Historical accounts from the eighteenth and nineteenth centuries testify to these talents, which were also renowned in Europe. An English visitor to Lancaster County during the early nineteenth century

described seeing "the most extensive views of cultivated nature that I saw in the United States."[1] "If we may make a distinction where all are excellent," wrote Oscar Kuhns in 1901, "the Mennonites may be said to illustrate to the highest degree the skill in agriculture."[2]

This farming culture was part of a larger pattern of life and faith that remained powerfully connected to the past. Founded on the premises of nonresistance and nonconformity, Mennonite culture rejected engagement with the so-called "worldly world" in an effort to create an ideal Christian society on earth. Daily life centered around the nuclear family and on family farms, whose preservation was at the heart of cultural and religious continuity.

Founded in the mid-sixteenth century and named after Menno Simons, the Mennonite sect refused infant baptism, religious establishment, and military service. Participation in modern life was permitted up to a point, but, despite being less conservative than the Amish, the Mennonites still cultivated a parallel universe, profoundly self-contained and disengaged from many modern customs and values. Nicknamed "plain people," they adopted simple, archaic forms of dress as the visible mark of their separateness from the larger culture in which they lived. Their humility—and also their precision—is suggested by an anecdote from the Eby family history, which records that the barn of one of the first Ebys to settle in Elizabeth Township, Lancaster County, was built to be 99 feet long, "so as not to offend a neighbor who shortly before had built a barn of the boasted length of 100 feet."[3]

Apart from his attendance at a secular grade school, Rohrer's early education occurred within a religious framework that was complemented by weekend attendance at church with his family, sometimes up to three times a day. His high school education took place at Lancaster Mennonite School, formerly called the Yates School, which his maternal grandfather had helped found. He was the only one of his siblings to attend college, leaving Lancaster County to enroll in Eastern Mennonite College in Harrisonburg, Virginia, in 1945. One of the most momentous experiences he later recalled from those years was a 1946 trip to Poland with a

Mennonite group undertaking the good works of helping to replenish cattle herds ravaged during World War II.

Rohrer's experience of a world beyond his immediate community occurred within the context of a loosening of proscriptions against Mennonite participation in the worldly world following World War II. But even in the context of these broader changes, which were both casual and institutionalized, Rohrer's mounting decision to become an artist meant not only flouting family and community expectations that he would become a farmer and minister. It also implied a conflict between the assertion of individuality inherent in his choice and the emphasis on collective identity that was part of his background. As Rohrer said in a 1991 talk to a Mennonite audience about his decision to become an artist: "The celebrated practice of nonconformity did not seem to allow me the right of individuality."[4]

After attending college at Eastern Mennonite College, where he majored in Bible studies, he continued on to James Madison University, studying art education and art, including classes in painting. His first contact with professional artists occurred at Pennsylvania State University in 1952, where he studied with Hobson Pittman, a professor at the Pennsylvania Academy of the Fine Arts who taught a summer program there. Rohrer first started painting in *plein air* and was quickly rewarded with selection for the American section of the 1955 Pittsburgh International Exhibition of Contemporary Painting. In 1961, following a summer painting in Nova Scotia, he returned with his wife Jane and sons Jon and Dean to live in Christiana, Pennsylvania, not far from his birthplace, to paint.

Ten years later, still living in Christiana, he began to rethink the relationship between his painting and his biography after visiting an exhibition called *Abstract Design in American Quilts* at the Whitney Museum of American Art.[5] The Whitney exhibition was one of the first to look at quilts in aesthetic terms rather than as historical objects. The quilts included in the exhibition were selected on the basis of their resemblance to contemporary abstract paintings. The catalogue bore a dedication to Barnett Newman, a friend of

the organizer, Jonathan Holstein. Like Newman, who had championed art made by anonymous early Americans—Pre-Columbian sculpture, Northwest Coast Indian art—Holstein argued that quilts, quintessentially American objects made by anonymous artists, should be appreciated as an important native art form rather than as interesting ethnographic artifacts. Rohrer was especially impressed by a group of quilts designed in Lancaster in the mid-nineteenth century but unlike any he had ever seen: spectacularly minimal, vividly colored, and geometrically rigorous in design (fig. 4). Within months of this exhibition in 1971 he and his wife began to collect this kind of Amish quilt. In a preface written for an exhibition of quilts presented at Philadelphia's Moore College of Art and Design in 1978, Rohrer compared these quilts to "modern art . . . brooding in color like Rothko."[6]

Rohrer connected the order he recognized in quilts to the ordering of the landscape he knew so well. He identified both elements with an essential aesthetic statement that he

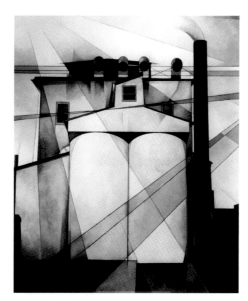

Fig. 5. Charles Demuth (American, 1883–1935), *My Egypt*, 1927. Oil on composition board, 35 3/4 x 30 inches (90.8 x 76.2 cm). Whitney Museum of American Art, New York. Purchase, with funds from Gertrude Vanderbilt Whitney, 1931.

Fig. 6. Barnett Newman (American, 1905–1970), *The Third*, 1962. Oil on canvas, 101¹/₂ x 120¹/₄ x 2 inches (257.8 x 305.4 x 5 cm). Walker Art Center, Minneapolis. Gift of Judy and Kenneth Dayton, 1978.

strategies of modernist painting—the emphasis on flatness, geometry, surface—led Rohrer to reexamine Lancaster traditions and forms, and, in turn, to reinvent his approach to painting following the close of his December 1971 exhibition at Philadelphia's Makler Gallery.

The show would be his last at Makler, because the scale of his work grew too large for the gallery's small space and because Rohrer's new concerns would find a more appropriate home at the Marian Locks Gallery, which has represented the artist with only one hiatus from 1972 to the present.[7] The painting pictured in the Makler announcement (fig. 1), *Farm: August,* 1971, would return to Rohrer's studio, where he took turpentine to its variegated and complex surface, erasing and simplifying it—a ground-clearing in more ways than one. For the moment, this was merely an act of negation as he searched for a new way of working—although the gesture of painting on the canvas and then wiping the surface away to begin anew would be incorporated into his working process for the rest of his life.

In February 1972 a group of professional people from Lancaster County, led by Rohrer's lawyer, Sam Musser, sponsored a trip for the artist to live and paint on the island of Corfu in Greece, and then to travel in Greece, Italy, France, and Holland. This trip culminated with visits to retrospective exhibitions of the work of Barnett Newman (fig. 6) and Mark Rothko (fig. 7) at the Stedelijk Museum in Amsterdam and the Musée National d'Art Moderne in Paris, respectively.[8] Both artists had died in 1970, and the following year the Rothko Chapel had opened in Houston. While a new generation challenged the heroic ideal of abstract expressionism, the open-ended spirituality of Rothko's painting and also Newman's sculpture were being enshrined in a nondenominational, ecumenical, and museum context associated with the Menil Collection.

Rohrer later described his 1972 European trip as a time when he was debating "what kind of painter I want to be." As he said, "It was my decision at the end of that trip that I had to become more related to painting being the object and dealing with abstraction in a more serious way."[9] Another

wanted to embrace. Previously he had approached the landscape as an outsider taking in a view. Now he would look to farming and to the functional forms of Pennsylvania Germans as reflections of the precision and simplicity that were basic principles of his painting. Quilts would remain a touchstone as he searched for an artistic language that would transcend the outward appearance of Lancaster yet still suggest the conceptual and formal essence of place.

This recasting of artistic identity calls to mind a Lancaster-born painter from earlier in the century, Charles Demuth, who would often revisit the architecture of his birthplace. To paintings such as *My Egypt* (fig. 5)—a representation and celebration of a nineteenth-century grain elevator—Demuth brought his experience of urban modernism, which shaped his choice of a subject, but also his treatment of it in terms of a fractured cubist space. Aesthetic

question he faced was what would be *his* artistic signature—an issue highlighted by his confrontation with the work of two artists identified with the invention of signature styles of American art in the postwar period.[10]

On his return in 1972 he adopted the grid as the formal and poetic equivalent for his lived experience of rural Pennsylvania. From then on he painted only in a square format of 60, 66, or 72 inches. This change occurred at a time when the grid was ubiquitous among contemporary artists, prominent among them the painter Agnes Martin (fig. 8), who had been especially visible in exhibitions of minimalism at Philadelphia's Institute of Contemporary Art and the Philadelphia Museum of Art.[11] An emblem representing either impersonal rationality or otherworldly spirituality, the grid offered an endlessly self-generative starting point to which the artist could return anew. Traveling between this abstract framework and his accumulated perceptual knowledge, Rohrer put his unique imprint on this structure, making it an expression of subjective and cultural sensibility.

Barley (pl. 1), completed not long after his return from Europe, applies an irregular grid to a brilliant, saturated orange field. This new sense of "minimalism" and reduction to simplest means projects a powerful sense of light, partly borne of his recent experience abroad. "I saw this fantastic light on Corfu. Then I saw it in Italy, in Greece and in France. And when I came home, I saw it in Lancaster County."[12] Combining intense color with a concise, ordered system of marks, he achieved a distinctive pictorial economy, a characteristic he admired in the paintings of Newman and Martin. Through a vocabulary based on fine distinctions between surfaces and the marks on top of them, he translated his fascination with the allover patterns found in nature—such as hornets' nests or melon rinds—into mark-making systems that inspired paintings. The fleeting landscape experience became the basis for *Barley,* and he later recalled being drawn to "heads of barley seen in relationship to the blaze of light."[13] His application of dark marks over pale marks suggests shadow, just as *Corn: Stubble* (pl. 2) was inspired by a "field of stubble rows which leaned, some to the left and

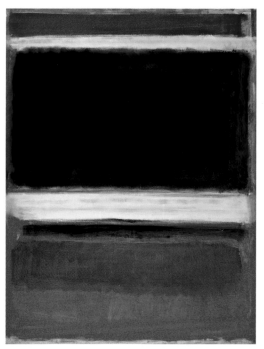

Fig. 7. Mark Rothko (American, born Latvia, 1903–1970), *No. 3/No. 13 (Magenta, Black, Green on Orange)*, 1949. Oil on canvas, 84 1/2 x 64 1/2 inches (215 x 164 cm). The Museum of Modern Art, New York. Bequest of Mrs. Rothko through the Rothko Foundation, Inc.

some to the right due to the direction traveled by the cutting machine moving in and out of shadow."[14]

Like *Barley, Corn: Stubble* is based on an image and memory; however, it is constructed according to mark-making procedures determined in advance of beginning the painting. By rhythmically loading and unloading the paintbrush in the course of its horizontal movement across the canvas, the artist introduced changes in the density of individual marks but also a randomness to the way the work unfolds. This same process had guided Robert Ryman in the making of his *Winsor* series in 1965–66, one of which was presented in Ryman's 1972 exhibition at the Solomon R. Guggenheim Museum. Whereas Ryman laid down long, even strokes that spread the length of the canvas, Rohrer emphasized the rhythmic juxtaposition of individual marks.

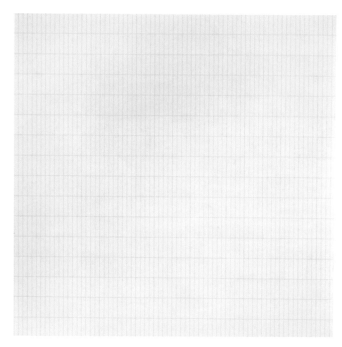

Fig. 8. Agnes Martin (American, born Canada 1912), *The Rose*, 1965. Acrylic and graphite on canvas, 72 x 72 inches (182.9 x 182.9 cm). Philadelphia Museum of Art. Centennial gift of the Woodward Foundation, 1975 (1975-8-1).

In *Corn: Stubble,* Rohrer incorporated the teeth of individual brushstrokes as a compositional and structural element, a technique that recalls the work of African American painter Alma Thomas, another nature painter and modernist painter working outside of the artistic center of New York—in Washington, D.C. (fig. 9).[15] Rohrer included a secondary system of marks: small vertical lines drawn with a paintbrush in two different colors. At the top of the canvas these elements are in sync with the horizontal system of marks, alternating like warp and weave. Gradually the two diverge, which calls attention to the artist's use of measurement and counting to generate the structure. His use of numerical calculation would become more complex, and assume greater importance, as Rohrer relinquished a painting vocabulary based on the metaphorical connection linking his painting to the process of cultivation.

When in 1974 he created two different series of paintings, he began to vary his procedures, exploring structural variation as a way to generate a related group of works. Completed in 1975, the series of *Atmosphere* paintings ultimately numbered three and the *Pond* paintings numbered nine. In both series he began by painting the surface and then wiped off the first coat of paint—with the result that a nearly translucent layer of pigment nestles in the folds and the textures of the surface, emphasizing the physical character of the canvas as a fabric. This interest in tactility, shared with textiles and craft and built into the physical structure of his painting, also extended to the system he adopted in advance to make *Atmosphere 1* (pl. 3), for example.

The artist made the relationship of his body to the canvas an element structuring the space between marks and the canvas's borders. His decision about the length of each row of marks was determined by the measure of his outstretched arm and the curve it made as it fell naturally. Into the first layer of marks he then "implanted" a system of delicately dotted colors, according to a rigorous system of counting. He attached metaphors borrowed from the realm of farming to his exploration of the internal structures of the (modernist) pictorial field. The notion of building a series of marks that

suggested planting became the basis for a vocabulary providing a new system, just as his treatment of borders and edges of a canvas surface became another way to connect processes he imagined taking place on two related but different fields: that of a farm and that of a painting. "The painting now becomes the field on which I do my work. I mean my heritage as a farm boy or growing up in the generation of farmers . . . the field is where you go out and do your work. It's a matter of you plow, you cultivate, you harrow, you cut, you harvest and there is a boundary. The fencerow is something that has to be reckoned with. You go to the edge and the activity is going to be an acknowledgement of what those edges are."[16]

Interested since his years at Penn State in the kinetic basis of children's earliest scribbles—a specialty of a pioneer of art education, Victor Lowenfelt—he was also likely touched by the more recent fascination with French philosopher Maurice Merleau-Ponty. His essay "Eye and Mind" discusses the important connection between the artist's body and vision and seems to have informed Rohrer's ongoing exploration of ways to engage the viewer's body, as well as his eyes, in relating to a canvas.[17] Indeed, he experimented with this question in the *Atmosphere* paintings, adding to the surface a layer of pale paint infused with medium that made for a secondary pattern of greater reflectivity, but visible only from the side and not from the front. The painting necessitates viewing from close-up but also encourages being looked at from different angles.

The pond (fig. 10) on his Christiana property had captured Rohrer's imagination in a series of shaped paintings that he made in 1969. At that time he had first experimented with a radically different approach to the landscape, cutting plywood shapes and painting them. He conceived these objects as excerpts taken from nature, and he arrived at their forms through a process of repeated observation and drawing of spaces within nature, such as those between a tree's branches or the contour where two hills meet or the shape of the edge of the pond. Rohrer painted these shapes on either side to suggest a different light "situation" at various times of the day or season, distilling his response to the landscape

into what he called a "one color statement"—a description that suggests the artist's desire to join the concerns of Impressionism and the momentary to those of contemporary monochrome painting and the search for the essential.

Created at a moment when the idea of shaped paintings and the idea of objects that exist on the border of painting and sculpture were both widely discussed in the New York art world, these shaped paintings show him imagining this possibility on his own terms by looking to models close at hand. Sanded to achieve their stark, matte surfaces, the shapes distantly recall the tradition of folk signs—among the first art objects he remembered from childhood—but also the painted wood surfaces of country barns. Indeed the artist presented these objects hung from wire. Unsatisfied with the results, he put the shapes back in the environment that inspired them and had them photographed, in a tree or posed next to a pond. Placed back in the landscape, these forms suggest figural forms and look like bodies.[18] Reflecting his growing desire to find an elemental form that embodied

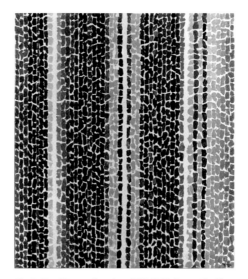

Fig. 9. Alma Thomas (American, 1891–1978), *Breeze Rustling Through Fall Flowers*, 1968. Acrylic on canvas, 58 7/8 x 50 inches (149.5 x 127 cm). The Phillips Collection, Washington, D.C. Gift of Franz Bader, 1976.

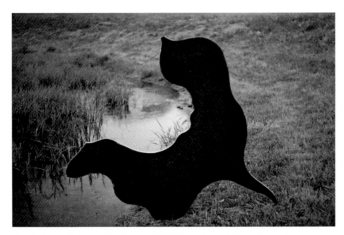

Fig. 10. Warren Rohrer, *Water Shape*, 1969. Paint on plywood, dimensions unknown.

the landscape, the shapes, as he later remembered, were made at a time "when I started making the landscape become object, as opposed to becoming paintings about the landscape."[19]

In the series of *Pond* paintings that he began in 1974 he looked back to this early treatment of the pond surface as a painting surface, but now his concern was not with solidity but with its opposite. Comprised of delicate alternations of lines and spaces moving horizontally across the surface, *Pond 5* (pl. 6) diagrams water as a changing pattern of light in space, ethereal and fugitive. Its painted parallel lines change in density, tone, and reflectivity as they move from left to right. Although he was looking at a small pond on his property, he may also have been thinking about Philadelphia-born painter Thomas Eakins's paintings of the Schuylkill River (fig. 11), based on perspective drawings

transcribing water rippling on the river's surface as an elemental configuration. Like Eakins, Rohrer combined graphic precision with painterly atmosphere, a reflection of his interest in mathematical method as well as in intuitive and random events that occur while painting.

Throughout Rohrer's career he would often reach back to the nineteenth century as a point of reference, owing to his affinity for artists who romanticized the rural experience that Rohrer had lived. His longstanding interest in earlier traditions of landscape painting was reinforced by scholarship and exhibitions reexamining nineteenth-century landscape traditions as precedents for twentieth-century abstraction, including abstract expressionism, such as Robert Rosenblum's 1975 book *Modern Painting and the Northern Romantic Tradition* and the 1976 exhibition *The Natural Paradise* at the Museum of Modern Art.[20]

In *Moon 1* and *Moon 2* (pl. 8) Rohrer paid tribute to American landscape painters Albert Pinkham Ryder and Ralph Albert Blakelock. He had written a paper on Ryder's work in 1954—a paper that reads, in retrospect, almost as a manifesto of Rohrer's artistic ideals. Through their titles and colors, *Moon 1* and *Moon 2* refer to the moonlit scenes that brought both artists recognition. In *Moon 2* minutely detailed marks evoke the seeding of a ground as well as suggesting the characteristic single-color-on-single-color stitching of the quilts Rohrer collected. The painting also veers from the strict horizontality of parallel lines in Rohrer's previous work, introducing a wavy directionality that he would explore to dramatic effect in his mid-1980s paintings. When he wrote a statement for the exhibition *Pennsylvania Quilts: One Hundred Years, 1830–1930* at Moore College of Art and Design, he argued that the Amish discovered the patterns of their quilts from the order of the farmed landscape.[21]

Dormant (pl. 7) incorporates a palpable reference to a cultivated field, which exists in tension with his equally prominent emphasis on pattern and process. Rohrer imbued the painting with light by allowing the white ground to emanate powerfully from beneath the horizontal and diagonal dotted lines that cover the surface. The large horizontal

bands of this painting suggest the "bar" patterns of Amish quilts but also connect to the format of paintings premiered by Agnes Martin in New York in 1975. In contrast to the simple stripes of pale hues, characteristic of Martin's works, Rohrer's layered patterns allude to the parting and piling of grasses after a field is plowed. At a time when the stricture of flatness was such an undisputable premise of modernist painting,[22] *Dormant,* even more than the *Moon* paintings of the same year, assumes a continuity between landscape painting of the past century and abstraction of the postwar period.

This continuity was affirmed when, in the summer of 1977, Rohrer was invited to be a visiting artist at Emma Lake Workshop. Rohrer traveled with his wife Jane on a cross-country drive to Saskatchewan. Founded by the University of Saskatchewan in 1936 as the Murray Point Summer School of Art at Emma Lake, this summer artist's residency program's history was almost perfectly matched to Rohrer's own artistic trajectory. The school's formation was inspired by the outlook of a professor at the university, Augustus Kenderdine, whose teaching was modeled on painting after nature in the manner of Barbizon and Impressionist painters of the nineteenth century. However, Barnett Newman's legendary visit in 1959 and Clement Greenberg's visits in 1962 and 1963 had made it something of a Canadian and Western outpost of modernist painting.

While at Emma Lake, Rohrer gave workshops but did not paint. On his return to Christiana, his work showed the impact both of the new landscapes he experienced and the new museums he visited, but also reflected a process of paring down and beginning again that he had gone through five years earlier. In 1977 there was more to be salvaged than rejected, as his interest in painting ineffable conditions of light and fog translated into a concern with the perceptual effects of a painting and the further elimination of landscape references. Rohrer's interest in marks and mark-making assumed a life of its own, coalescing into a consistent and cumulative approach. Whereas in the early 1970s a painting might consist of a ground and a row of marks, varying in color or density, now his layers became more complex.

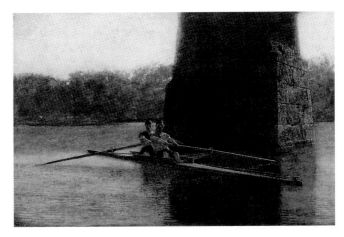

Fig. 11. Thomas Eakins (American, 1844–1916), *The Pair-Oared Shell,* 1872. Oil on canvas, 24 x 36 inches (61 x 91 cm). Philadelphia Museum of Art. Gift of Mrs. Thomas Eakins and Miss Mary Adeline Williams, 1929 (1929-184-35).

Every variable he isolated in a painting—mark, edge, color—became animated. Incremental changes to these attributes accumulated to produce different visual experiences.

Rohrer now treated the fundamental element of his vocabulary—the individual brushstroke—as a modular unit to be repeated across the surface of the canvas as a series of objective marks. In this marriage of structure and procedure, his technique encompassed the rigorous brushwork application of Henri-Edmond Cross (fig. 12) but also the systematic ordering so central to contemporary artist Sol LeWitt (fig. 13). Repetition was the basis of this process, and the results record this obsessive technique performed not for its own sake but to achieve subtle patterns and surprising luminosity.

Certain principles remained consistent, including his treatment of each layer of marks as discrete and inviolable, continuously moving from left to right. Typically the pattern

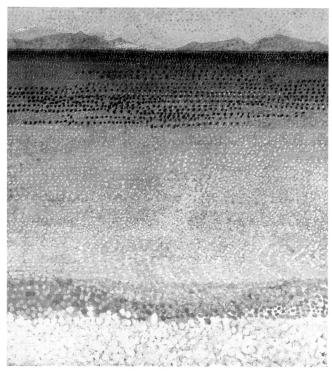

Fig. 12. Henri-Edmond Cross (French, 1856–1910), *Les Îles d'Or*, 1891–92. Oil on canvas, 23⅝ x 21⅝ inches (60 x 55 cm). Musée d'Orsay, Paris.

was strictly horizontal, but sometimes diagonal, and in the mid-1980s complicated bulging and swirling patterns were introduced. Regardless of the complicated layering of colors, the canvas's edges purposely reveal how the painting was made, as each new layer shows evidence of the previous one. Visual drama is heightened at the edges, owing to differently scaled marks, variations in color, and treatment of the surface ground.

Undetectable in the paintings but visible in undated drawings, diagrams, and color tests among Rohrer's papers is the enormous amount of preparation that went into the construction of a painting and the calibration of its palette (fig. 14).[23] Preparatory drawings on graph paper show numerical calculations used to regulate color and to organize the quadrants of a canvas. The drawings map a painting's invisible inner architecture. In their outward aspects they parallel diagrammatic drawings by such artists as Mel Bochner (fig. 15) who were fascinated by concepts of calculation, structure, and procedure.[24]

No subsequent painting would appear so nakedly reduced as *Flying Blue Diptych* (pl. 10), comprised of layers of blue and blue-green as well as tawny orange but reading as nearly monochromatic. Its lateral spread evokes the artist's recent experience of the vast scale of the West. Its emptiness and tonal subtlety bring to mind the panoramic landscapes of nineteenth-century American luminist painter John Frederick Kensett (fig. 16). Each row of brushmarks in this painting was applied according to mathematically determined intervals that are recorded in the "sheared" pattern at the bottom of the left-hand canvas. Alternating brushstroke with space—a technique of open brushstrokes that would also become a trademark—the artist produced a shimmering, flickering effect, reinforced by the interaction of lighter marks over darker marks. Seen from the side, the painting reveals its discrete layers and the changing density of different areas on the surface. The tension between the front view and the side view, or between the thinly painted and the thickly painted areas, remained an ongoing area of investigation in his work. The elongated shape and

distinctive surface pattern direct the viewer to peruse the painting by walking its length in an arc-like pattern.

Rohrer's desire to establish and work within a restricted range of technical and formal possibilities is also reflected in *Continual Shift: Winter White* (pl. 9). As in the 1977 diptych, each layer of the painting and each row of marks are treated as separate and independent, and the story of the painting's making is revealed at the edges, where its surface runs up against the limitations imposed by the canvas. After applying thinly washed stripes of orange and magenta to the ground, he introduced undulating hills and plow patterns in a second, gray layer of the painting. The pattern is nearly invisible, disclosed only at the lower-right corner. This pattern meshes optically with the layer of gentle diagonals on the uppermost surface, creating an effect such as might be seen in fabric, and suggesting the contouring of a hillside. Into this extraordinarily delicate pale surface he scratched a series of barely visible rows of marks, establishing a visceral and visual link between his treatment of the painting and the mark-making (plowing) of a field. In *Continual Shift: Winter White*, the inscription of the artist's presence within the canvas certifies a private identification between painter, painting, and landscape.

In *Christiana Boogie Woogie* (pl. 11), Rohrer preserved the framework of drifting, diagonal open marks common to *Flying Blue Diptych* and *Continual Shift: Winter White*. On top of a green wash, layers of yellow, blue, and pink were applied, alternating with bright red vertical markings that are prominent at the bottom but also visible at the top of the painting and even occasionally through the surface of its body. Conjuring the patterns of tall grasses, the overlapping brushstrokes at the top and bottom edges present evidence of the painting's construction, which is concealed by a blanket of diagonal marks. Contrasting with the primary colors that give the painting its title is a surface that gradually shifts from green to pink to purple.[25]

As the title *A Paler Green* (pl. 12) suggests, Rohrer was increasingly interested in color as a phenomenon existing on a continuum and perceived in degrees, rather than as a

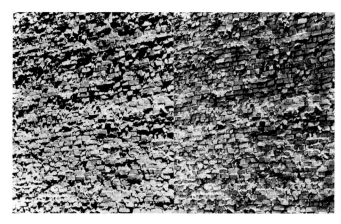

Fig. 13. Sol LeWitt (American, born 1928), *Brick Wall Series*, 1977. Gelatin silver print, 10 7/8 x 17 1/4 inches (27.6 x 43.8 cm). San Francisco Museum of Modern Art. National Endowment for the Arts. Purchase Grant and gift of Rene di Rose.

singular stable entity. The celadon glazes of Korean ceramics he had seen during his 1977 visit to the Cleveland Museum of Art had impressed the artist and inspired his iridescent palette in this and other works. Using a wider brush, he now emphasized minute changes in color between each line of marks and increased the color contrast between surface and underlayer. In *Walnut Black* (pl. 14), he focused on the apparent absence of color, making his first extremely dark painting. Despite its title, which derives from the walnut trees that grew on the Christiana property, the painting is not precisely black. Its surface is constructed from layers of brown, blue, and red, revealed on the left edge of the painting. In 1982, when the artist described his approach on the occasion of an exhibition at the Pennsylvania Academy of the Fine Arts, he could well have been referring to these slightly earlier works: "Each painting shows the relation of

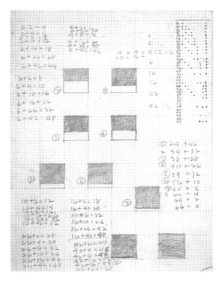

Fig. 14. Warren Rohrer, preparatory diagram, 1980s. Graphite on graph paper, 11 x 8 1/2 inches (28 x 22 cm). Estate of Warren Rohrer.

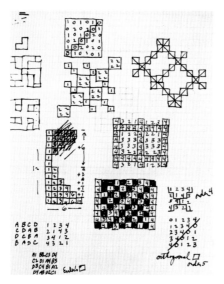

Fig. 15. Mel Bochner (American, born 1940), *Untitled (Euler's Square)*, 1966. Ink on graph paper, 11 x 8 1/2 inches (28 x 22 cm). Collection of the artist.

color to position. Each color is pure, diluted, dulled lightened warmed or cooled as it is uncovered and covered in the process of the painting. For only a moment is any color constant, as it makes visible its passage from one visual formation to another."[26]

In the 1980s, Rohrer started rethinking the relationship between the initial layer of paint and the surface layer, devising and varying his procedures of paint application. In *Settlement Magenta* (pl. 13), for example, the bottom layer is brushed on with a vibrant orange at the upper left, becoming more yellow throughout the center. Unlike prior paintings, there is a strong contrast between the bright surface and the dark layers of paint on top, giving the painting a powerful inner glow. A dark green applied with a large brush in diagonal patterns leaves areas of the yellow ground revealed, making it appear as if light is generated from within the painting. Using a thread to guide the mark-making process, the artist applied magenta brushmarks to the surface. Alternate marks in these diagonal rows are applied with a rhythmic twisting of the brush, creating intermittent triangular brushmarks that capture light, although the individual marks melt together, losing their identity. This is what Rohrer referred to when he wrote that "surface preempts structure."[27] The palpable glow of the undersurface, combined with the richly textured upper surface, recalls the light of nineteenth-century British painter Joseph Mallord William Turner's late works (fig. 17). At the bottom of the painting, where the marks change direction and color, a gentle ellipsis is created, suggesting a horizon line. The title of the painting comes from this area of darkening, where the artist imagined the pigment was "settling." The dramatic, saturated color predicts the artist's chosen palette after 1983.

Rohrer exhibited a group of paintings at CDS Gallery in New York in 1983, including *Conflicting Thought* (pl. 16), which show a heightened palette and the ongoing exploration of subtle color gradations. He calculated color transitions using the Fibonacci number sequence to determine proportional changes of hue and tone. An additive mathematical series (first discovered in the Middle Ages), widely recognizable

in nature, its pattern (1, 2, 3, 5, 8, 13) is reflected in the way a shell spirals or a tree branches. Perennially fascinating to artists, the Fibonacci sequence was popular during the 1970s, when, for example, Donald Judd, Mel Bochner, and Robert Smithson used it to depersonalize artistic decision-making and to position their work in relation to criteria that were not purely artistic but seemingly objective. Rohrer's interest in the Fibonacci sequence reflected a desire to establish a link between nature, the artist, and his work, and to establish his painting as concerned with the essence of nature, if not its outward appearance.[28]

In contrast to the regularized geometry of Rohrer's system of brushstrokes, these 1983 paintings are built from organic, undulating surface patterns, which together with the color shifts, produce a sense of volume. Looping and criss-crossing script-like marks peer out from the bottom edge of the painting. In *Deluge* (pl. 15) the surface is a dramatic swirling pattern, a homage to Leonardo da Vinci's deluge drawings. Rather than being vividly colored, *Deluge* is steely white-gray. Here the painting's internal architecture—including the artist's first application of a linear web—is visible on the bottom and left edges, creating a tension between the mosaic-like surface construction and the drawn marks on the relatively naked ground.

The year 1984 would bring changes, both personal and artistic. After living in Christiana for more than two decades, Warren and Jane Rohrer moved to the Mount Airy section of Philadelphia, to the former studio of Violet Oakley—a dramatic cathedral-like space where Oakley had painted the murals for Pennsylvania's State Capitol. Even before moving to this setting, on the edge of Fairmount Park but a short drive from Center City Philadelphia, Rohrer began to renegotiate his relationship to the Lancaster landscape through color, while at the same time memory became an explicit collaborator in the making of his work. As he noted in his journal: "Certainly this is a period of transition. The auguries of Lancaster County are different than those here in Fairmount Park and constitute a change of visual experience. . . . It seems impossible to chart the trail of what one sees to

Fig. 16. John Frederick Kensett (American, 1816–1872), *Shrewsbury River, New Jersey*, 1859. Oil on canvas, 18 1/2 x 30 1/2 inches (47 x 77.5 cm). New-York Historical Society, on permanent loan from the New York Public Library, Stuart Collection.

what one puts on the canvas and the memory of Lancaster County and all memories mixed with the physicality of my present environment will undoubtedly result in a updated configuration with the field of my painting interests."[29]

Two Elements (pl. 17) reveals these sources of inspiration that resulted in new configurations in his painting. Traveling between Center City and Mount Airy focused his attention on the Schuylkill River, and he decided to make a painting of it, even setting up a camera and tripod one day to photograph. The results are singular within his work, and the painting bore little connection to prior works inspired by water. The painting makes visible a language of rippling graphic marks hidden in his paintings of the previous year. *Two Elements* is one of a succession of works made between 1984 and 1986 that stand outside of the artist's customary development of his work according to serial shifts.

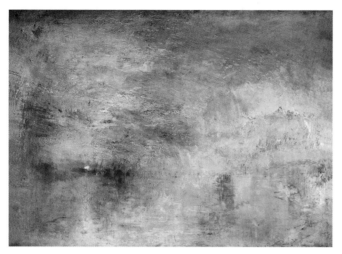

Fig. 17. Joseph Mallord William Turner (English, 1775–1851), *Sun Setting Over a Lake*, c. 1840. Oil on canvas, 36 x 48 inches (91 x 122 cm). Tate, London. Bequest of the artist, 1856.

Variation on Equation (pl. 18) announces the relinquishment of systems as its system, inaugurating a much more intuitive approach to composing. From 1984 onward, the artist's work is characterized by exuberant color; however, its organization eschews the orderly principles and consistency that for the most part had been a kind of motor within Rohrer's art for the last decade. Its elaborately varied vocabularies draw on mark-making systems the artist had treated in separate bodies of work but never combined. In its abrupt color transitions and coloristic intensity this painting is a major departure. The division of the surface into separate zones of atmosphere recalls the classic work of Rothko. The top section is comprised of halo-like wave patterns in purple and ocher. The central and largest area includes dark, looping marks visible throughout the body of the painting but covered with dramatic diagonal marks of subtly changing colors. The bottom section encompasses a wide variety of approaches, including textured marks made with combs. A compendium of different ways of painting, *Variation on Equation* analyzes and summarizes painting languages that Rohrer had evolved over more than a decade.

The artist had written in his journal of his desire to make a large-scale painting that had the quality of a small-scale painting: "I've been toying with the idea of working the large canvas in a manner appropriate to the smaller ones—this could be done with one or several small areas being developed on a large ground—or working successive layers wet on wet and developing the continued thought by sections."[30] As in paintings he made on a smaller scale beginning in the mid-1980s, in *Variation on Equation,* which is 72 inches square, different parts received different treatments, with the result being at once monumental and intimate as details disperse attention rather than focusing it on the whole. When he worked on a small scale, he addressed the canvas like a piece of writing paper, amplifying the identity and variety of individual marks. Throughout the 1970s he had occasionally made small paintings, but from 1984 to 1987 the number of paintings he made in the size of 12 to 15 inches square nearly equaled the number of paintings he made in

the range of 60 to 72 inches square. An obvious precedent for this approach lies in the example of Robert Ryman. Both made size irrelevant to the issue of scale.

The small works incorporate vocabularies he had perfected in the large works, but because they are less systematic, looser, more direct, and executed more rapidly, a great deal of invention also occurs during the process of making them rather than before commencing. They have more texture, as some paintings, such as *Augury 1* (pl. 19), are made with a palette knife and wet-on-wet application; others are scratched into with a comb or the back end of a brush, which mark-making does not conceal in order to reveal. The surface of *Husk* (pl. 22) relates to the repetitive mark-making that Rohrer adopted in large works of the same period, but here these marks organize themselves on top of the ground, almost like the image of a thumbprint or the pattern of a leaf. *Legend* (pl. 21), on the other hand, has a surface so physical and textured that it looks like baked clay. *Legend, Untitled* (pl. 31), and *Untitled 5* (pl. 28) include the imprints of the artist's hands on their edges, physical marks that imply the presence of the artist in the painting. The same physicality is inscribed in *Field: Crossover* (pl. 30), not only in the writing-like drawing made by scratching into the surface, but also in the force and tension between the two panels of the diptych, which has the presence of an open book. The two *Untitled* paintings from 1992 and 1993 blur the boundaries between painting and writing even more explicitly, as Rohrer used a vocabulary of pictorial signs inspired by the Lancaster landscape, isolating each as if it were a fragment of a larger alphabet or tablet.

Rohrer had been forming this alphabet since 1987, when he regularly began to photograph the landscape in Lancaster County, an activity he continued until 1993. On a weekly basis he drove from his home in Mount Airy to a field in Caernarvon, later affectionately named by friends and family "Warren's Field." Over the years he shot hundreds of photographs, carefully dated, and also made sketches in this hilly field terrain at a bend in the Conestoga River, near where his ancestors had first settled. The diptych *Caernarvon 2* (pl. 24) records the talismanic force of this place, taking the process of returning to this site of origins as its point of departure. Continuing in the more intuitive approach that had taken hold in the previous two years, the painting is comprised of rows of repeating curving arcs, an iconic sign for the Lancaster field become painting. The layering of thick marks over thin paint and the pink and bronze coloration produce an effect reminiscent of mosaic, while the obsessive energy informing the repeating halo-like pattern and texture summons comparison with Van Gogh, an artist of enduring importance and renewed interest for Rohrer in the 1990s.

In 1990 the artist began to translate the natural marks and signs of the Caernarvon landscape into visual and written equivalents for the richly layered information about people and time, embedded in this historic and present-day landscape. Part looping shorthand letters, part primitive icons of figures and animals, the vocabulary informs *Field: Twenty Minutes in June* (pl. 23), a painting also inspired by his experience of the landscape of the Shenandoah Valley in Virginia, where he traveled yearly to visit his wife's family. As Jane recalled, they stopped at a lookout point along the drive and noticed a curious sign: it indicated that when the light hits a certain point in the valley, it means there are only twenty minutes until darkness. The title, borrowed from the sign and situation, records his fascination with the particular coincidence of time and light as explored in a painting that shifts between light and dark but not in the conventional manner of using color or tone. Instead, the contrast of purity, texture, and density achieves the transition, and paradoxically the suggestion of darkness is achieved by introducing increasing amounts of whiteness.

In the ten *Field: Language* paintings he made in 1990 and 1991 the artist drew more directly on photographs and sketches inspired by the Caernarvon field, images that record changing contours of the land, the evidence of plowing and of seasonal change, and the varied patterns and colors made by the stubble of crops mowed down. All of these elements of a landscape were reexamined when he returned to his studio on the edge of Fairmount Park to develop these

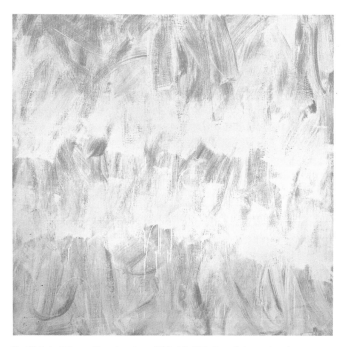

Fig. 18. Robert Ryman (American, born 1930), *VII*, 1969. Seventh in a series of seven panels. Enamel on corrugated paper, 60 x 60 inches (152 x 152 cm). Stedelijk Museum, Amsterdam.

configurations into a pictographic language suggestive of letters, tools, and figures. Drawn with oil stick on tracing paper, these shapes were pressed directly onto the canvas and the imprints reinforced with oil stick but also partly submerged as paint layers built up around them. In addition to this indexical procedure, the composition involved a collage-like process of locating these images within the canvas field separated into three separate zones.

In *Field: Language 9* (pl. 25) the curving, crisscrossing, organic writing is embedded in a field surface constructed from marks that drift to the diagonal, the colors and textures ebbing around the floating graphic elements. The lower zone of the painting establishes a flat surface on which a script-like scrawl threads itself, dancing horizontally from one edge of the canvas to the other. In *Field: Language 10* (pl. 26) the canvas is similarly divided into two zones, the lower zone,

predominantly blue and ocher, and the upper, predominantly white but incorporating subtle horizontal divisions that organize how the script is dispersed. Where the graphic language of *Field: Language 9* includes allusions to the figure and the suggestion of a possibly ancient language of signs, *Field: Language 10* evokes not only letters but a pictographic language of images and scribbles suggesting a child's tentative efforts at the boundary of writing and drawing. This is especially so in the lower section, where these marks become tightly knit and obsessively repeating. At the bottom right corner of *Field: Language 10*, the revealed white ground suggests a torn textile.

This row-by-row framework informs *Back and Forth* (pl. 27), in which the *Field: Language* vocabulary conforms to a horizontal structure that reprises the rhythm and approach of his 1970s paintings. The traces and movement of partially concealed marks and the whiteness of the palette evoke Ryman's 1969 painting *VII* (fig. 18). But in contrast to the simple delicacy of Ryman's abstract gestural statement, Rohrer's painting reattaches mark-making to a symbolic language that is inextricable from the landscape even if its message cannot be directly decoded. Rohrer's title, *Back and Forth*, derived from the Greek word *boustrophedon*, refers to the movement of writing from left to right and right to left but also to the movement of a plow through fields in this same pattern.

In the last years of Rohrer's life, the dialogue between two joined or consciously spaced canvases was his greatest preoccupation. He had painted two diptychs in 1977, paintings in which the lateral spread of the diptych's shape presented a larger arena to explore the questions of perception and light that led him to begin working in complex layers. In *Untitled 5* (pl. 28) Rohrer focused on the tension between the two components of the diptych, exploring the links and ruptures between the separate panels. He was interested in how each painting was perceived separately, as well as the two together. Drawing on his experience of traditional altars such as the great *Crucifixion, with the Virgin and Saint John the Evangelist Mourning* by Rogier van

der Weyden, in the Philadelphia Museum of Art, but also reinventions of painting formats by contemporary artists including Jasper Johns, Ellsworth Kelly, and Brice Marden, Rohrer extended into new directions ideas and techniques explored in the *Field: Language* paintings (figs. 19, 20).

As in that series, Rohrer arrived at a technique for referencing a landscape experience based on his indexical response to its characteristic language. During two trips to Vero Beach, Florida, he made drawings and rubbings of the trunks of trees and also closely observed the movements of palm branches in the wind. Preparatory drawings for *Untitled 5* show that he mapped the undersurface of the painting as a grid comprised of schematic drawings of individual palm branches. In developing the primary layers of the painting he used this indexical process evolved for imprinting the language of nature into paint. This technique of embedding the fossilized residue of experience into his work reflects his ongoing search for an unmediated language of nature within his painting, akin to his earlier reliance on mathematical procedure based on nature's systems.

The painting's dark surface nearly obscures the richly patterned understructure in bright orange, visible through the surface as "dots" or "explosions" of color but also as a striated texture. The final painting is released from the rigidity of the grid, achieving a powerful, dynamic swirling pattern, which contrasts with the smooth, pure edge of green running along the bottom of both panels. Each panel is different, but pictorial incidents shared between the two panels establish a dialogue between them. The experience of the painting is one in which the eye is constantly active and searching out tensions and dynamism in this conversation between elements that submerge and emerge from the surface according to the painting's organic inner rhythm. Meticulously constructed, its effects could not be more distant from the paintings he made two decades earlier, modeled on the fastidiously organized Lancaster landscape. Making a painting with such deliberately revealed layers engages the viewer in a process of archaeological investigation that, for Rohrer, went beyond the mere materiality of a surface. He called the painting's

Fig. 19. Brice Marden (American, born 1938), *The Dylan Painting*, 1966. Oil and beeswax on canvas, 60 x 120 inches (152.4 x 304.8 cm). San Francisco Museum of Modern Art. Helen Crocker Russell Fund purchase and partial gift of Mrs. Helen Portugal.

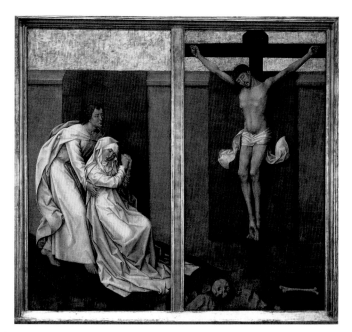

Fig. 20. Rogier van der Weyden (Netherlandish, 1399/1400–1464), *The Crucifixion, with the Virgin and Saint John the Evangelist Mourning*, c. 1450–55. Oil and gold on panel, left panel 71 x 36⁵/₁₆ inches (180 x 92 cm), right panel 71 x 36⁷/₁₆ inches (180 x 93 cm). Philadelphia Museum of Art. John G. Johnson Collection, 1917 (cats. 335, 334).

investigation of itself—what others might call "formalism"—a species of autobiography.[31] Searching for that originating layer was a metaphor for Rohrer's restructuring of his connection to this landscape through the process of painting and the empathetic looking that painting generates.

In the early 1970s, cultivation had proved the most important metaphor for his painting, and paintings from 1972 to 1976 tell the story of their making both transparently and honestly. In the late 1970s and early 1980s, painting and the invention of techniques for painting became extraordinarily systematic, achieved by the controlled variation of changes in palette, mark module, or relation of surface to ground and all layers in between. The sense of experimentation that emerged in the mid-1980s—the dynamic use of pattern and palette, volume and hue—corresponds to Rohrer's writings at the time. Instead of imagining himself entering each painting stroke by stroke, his words reveal a painter experiencing his work from within the very procedures themselves, as if he were inhabiting the shifting color or illumination and thinking a layer to make it. By the 1990s, however, Rohrer explicitly described his life's work as an investigation of origins, linking the local wellspring of his painting in Caernarvon, Lancaster, to the very process of artistic self-invention.[32] From a lived experience in which nature and spirit were inseparable, he encoded his abstract paintings with the residue of place and culture remade in a pattern announcing itself as universal.

1. See Isaac Candler, *A Summary View of America: comprising a description of the face of the country, and of several of the principal cities; and remarks on the social, moral and political character of the people: being the result of observations and enquiries during a journey in the United States. By an Englishman* (London: T. Cadell, 1824), p. 13. Quoted in Gloria Gilda Deák, *Picturing America, 1497–1899: Prints, Maps and Drawings Bearing on the New World Discoveries and on the Development of the Territory That Is Now the United States* (Princeton, New Jersey: Princeton University Press, 1988), p. 150.

2. Oscar Kuhns, *The German and Swiss Settlements of Colonial Pennsylvania: A Study of the So-Called Pennsylvania Dutch* (New York: Henry Holt, 1901), p. 86.

3. Richard Eby, *Eby Genealogy* (published by Lloyd M. Eby, J. Eby Hershey, John C. Metzler, and Paul H. Eby, 1979), n.p.

4. Warren Rohrer, notes for "A Consideration: Influences of Heritage and Place" (presentation given at The People's Place Gallery, Intercourse, Pennsylvania, November 8–9, 1991), Warren Rohrer Archives, Philadelphia.

5. See Jonathan Holstein, *Abstract Design in American Quilts* (New York: Whitney Museum of American Art, 1971).

6. Warren Rohrer, "My Experience with Quilts (A Bias)," in *Pennsylvania Quilts: One Hundred Years, 1830–1930*, exh. cat. (Philadelphia: Moore College of Art and Design, 1978), n.p.

7. Although Makler focused on classic modernist artists—Alexander Calder, David Smith, Marco Relli—the gallery represented only a small number of living artists from the area. The recently opened Marian Locks Gallery was committed to presenting contemporary Philadelphia artists.

8. The Newman exhibition opened at the Museum of Modern Art, New York, in October 1971 before traveling to the Stedelijk Museum, Amsterdam, among other venues. The Rothko exhibition was shown at the Musée National d'Art Moderne, Paris, in 1972.

9. Warren Rohrer, Oral History Interview by Marina Pacini, June 1, 1989, Archives of American Art, Smithsonian Institution, Washington, D.C., p. 223.

10. See ibid., p. 109: "I was aware of the fact that in my work there was perhaps not the distinctness in terms of what I thought an art statement had to be, a signature statement that related to what was going on at a certain time."

11. These exhibitions included *The Pure and the Clear* (1968), Philadelphia Museum of Art; *A Romantic Minimalism* (1969), Institute of Contemporary Art, Philadelphia; and *Grids* (1972), Institute of Contemporary Art. The year 1972 also saw the publication of John Elderfield's article "Grids," *Artforum*, vol. 10, no. 9 (May), pp. 52–59.

12. Rohrer quoted in David Osterhout, "Area Artist Chosen for Film to Be Shown Around World," *Lancaster New Era*, October 25, 1978, p. 54.

13. Rohrer, Oral History Interview, p. 224.

14. Ibid., p. 229.

15. Alma Thomas was the first African American woman to have a one-person exhibition at the Whitney Museum of American Art, New York, April 25–May 28, 1972.

16. Rohrer, Oral History Interview, p. 225.

17. Maurice Merleau-Ponty, "Eye and Mind," in *The Primacy of Perception and Other Essays on Phenomenological Psychology, the Philosophy of Art, History and Politics*, ed. James M. Edie (Evanston, Illinois: Northwestern University Press, 1964), pp. 159–90.

18. Foreshadowing Rohrer's paintings, and perhaps revealing the widespread influence of the philosopher Merleau-Ponty, the shape paintings also ask that the viewer move around them.

19. Rohrer, Oral History Interview, p. 215.

20. Robert Rosenblum, *Modern Painting and the Northern Romantic Tradition: Friedrich to Rothko* (New York: Harper and Row, 1975). See also Robert Rosenblum, "The Abstract Sublime," *ARTnews*, vol. 59, no. 10 (February 1961), pp. 37–40, 56–57.

21. See Rohrer, "My Experience with Quilts (A Bias)." For a recent discussion of Rohrer's ideas, see Sara Laurel Holstein, "Sewing and Sowing: Cultural Continuity in the Amish Quilt," in *American Artifacts: Essays in Material Culture*, ed. Jules David Prown and Kenneth Haltman (East Lansing: Michigan State University Press, 2000), pp. 93–108.

22. See Clement Greenberg, "Modernist Painting," in *Clement Greenberg: The Collected Essays and Criticism*, vol. 4, ed. John O'Brian (Chicago: University of Chicago Press, 1993), pp. 85–93.

23. David Hall (former student of Rohrer), personal communication, Philadelphia, August 8, 2001.

24. See, for example, Lucy Lippard and John Chandler, "The Dematerialization of Art," *Art International*, vol. 12, no. 2 (February 1968), pp. 31–36.

25. The painting's title was suggested by the artist's friend Neil Courtney, a member of the Philadelphia Orchestra.

26. Rohrer quoted in Sam Taylor, "One-Man Philadelphia Show Features Local Art," *Lancaster New Era*, February 22, 1982, p. 32. See also Warren Rohrer, artist's statement, *Warren Rohrer: Passage; an Exhibition of Paintings* (Philadelphia: Pennsylvania Academy of the Fine Arts, 1982).

27. Rohrer, journal entry, July 20, 1981, Warren Rohrer Archives, Philadelphia.

28. The mathematical calculations recorded in color studies the artist made to prepare for a painting also relate to the exercises that Rohrer's students from the early 1980s recall, which are recorded in the artist's notebooks from the 1980s: observing paintings in the Philadelphia Museum of Art and attributing a number to different colors in each based on the perception of color intensity or value. Stuart Elster (former student of Rohrer), personal communication, New York, October 19, 2001.

29. Rohrer, journal entry, 1984, Warren Rohrer Archives, Philadelphia.

30. Rohrer, journal entry, December 11, 1982, Warren Rohrer Archives, Philadelphia.

31. Rohrer, Oral History Interview, p. 238.

32. Ibid., p. 237.

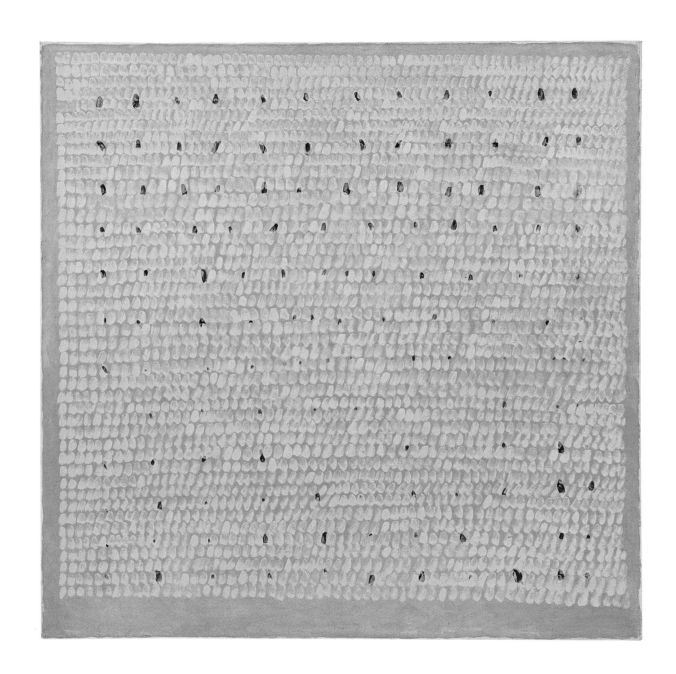

Pl. 1 **Barley**, 1972
Oil on canvas, 54 x 54 inches (137 x 137 cm)
Collection of the Rohrer Family

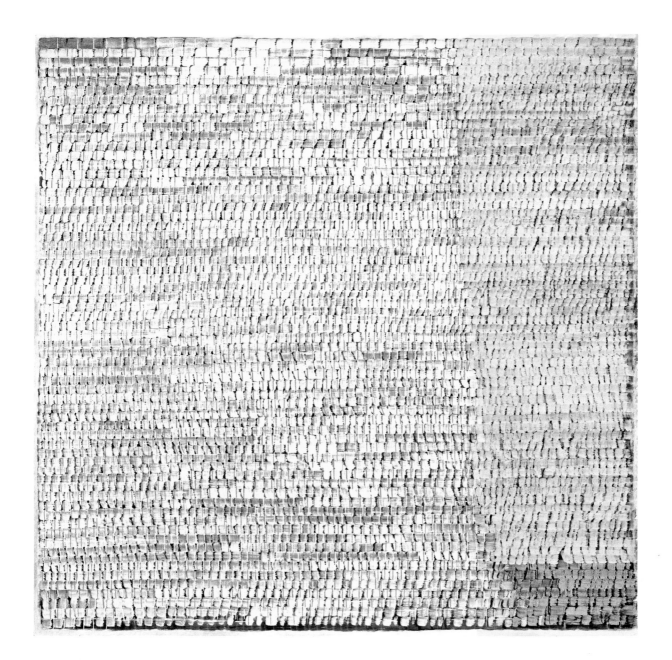

Pl. 2 **Corn: Stubble**, 1973
Oil on canvas, 72 x 72 inches (183 x 183 cm)
Collection of Ted and Kathy Hicks

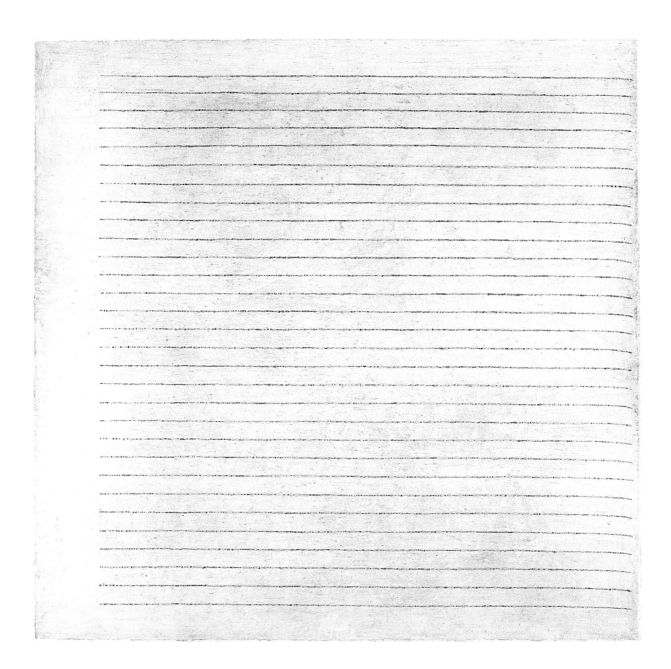

Pl. 3 **Atmosphere 1**, 1974
Oil on canvas, 66 x 66 inches (168 x 168 cm)
The Dechert Collection

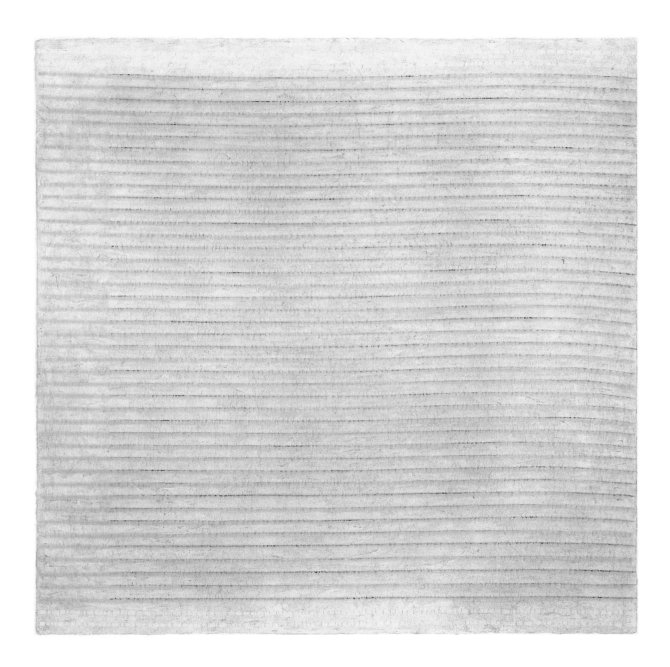

Pl. 4 **Atmosphere 2,** 1974
Oil on canvas, 72 x 72 inches (183 x 183 cm)
Collection of Mr. and Mrs. B. Herbert Lee

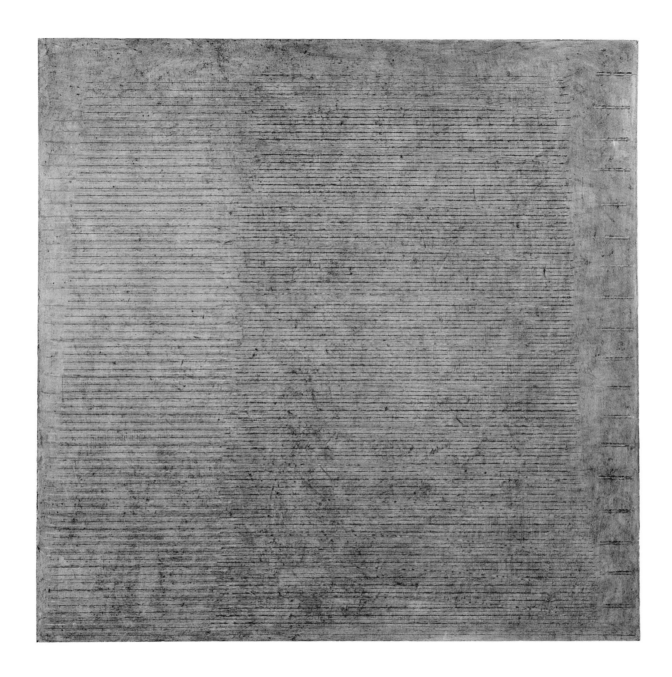

Pl. 5 **Pond 3**, 1975
Oil on canvas, 60 x 60 inches (152 x 152 cm)
Private collection

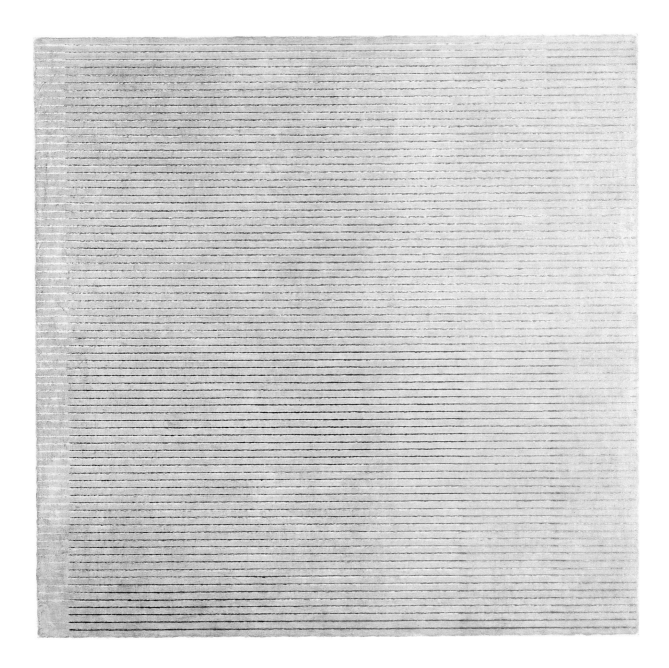

Pl. 6 **Pond 5**, 1975
Oil on canvas, 60 x 60 inches (152 x 152 cm)
Collection of Wilder Green

Pl. 7 **Dormant**, 1975
Oil on canvas, 72 x 72 inches (183 x 183 cm)
The McCrae Collection

Pl. 8 **Moon 2**, 1976
Oil on canvas, 72 x 72 inches (183 x 183 cm)
The McCrae Collection

Pl. 9 **Continual Shift: Winter White**, 1977
Oil on canvas, 66 x 66 inches (168 x 168 cm)
Collection of Robert Montgomery Scott

Pl. 10 **Flying Blue Diptych**, 1977
Oil on canvas, diptych, 54 x 108 inches (137 x 274 cm)
Collection of Mr. and Mrs. Jonathan Solomon

Pl. 11 **Christiana Boogie Woogie**, 1978
Oil on canvas, 66 x 66 inches (168 x 168 cm)
Collection of Duane, Morris, LLP

Pl. 12 **A Paler Green,** 1979
Oil on canvas, 60 x 60 inches (152 x 152 cm)
Collection of Robert and Ana Greene

Pl. 13 **Settlement Magenta**, 1980
Oil on canvas, 72 x 72 inches (183 x 183 cm)
Philadelphia Museum of Art. Purchased with funds contributed by Henry Strater and Marion Stroud Swingle, 1982 (1982-461-1)

Pl. 14 **Walnut Black,** 1980
Oil on canvas, 72 x 72 inches (183 x 183 cm)
Collection of the Rohrer Family

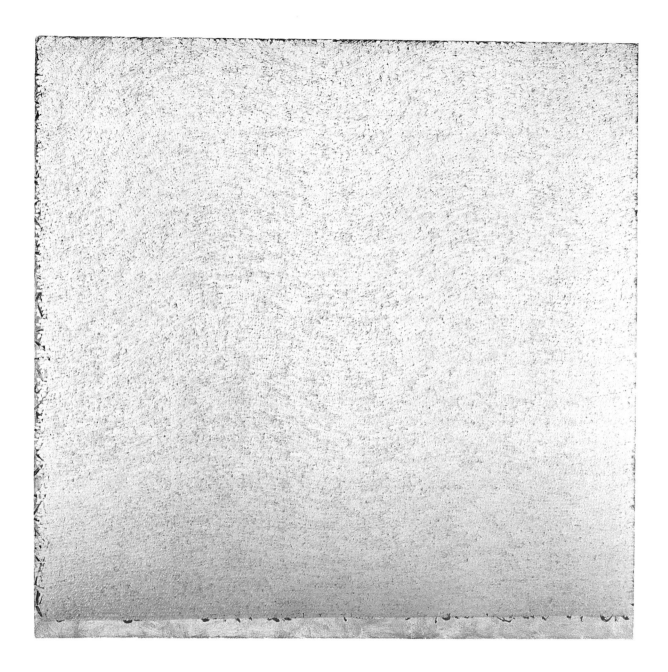

Pl. 15 **Deluge**, 1983
Oil on canvas, 66 x 66 inches (168 x 168 cm)
Collection of Bayard and Frances Storey

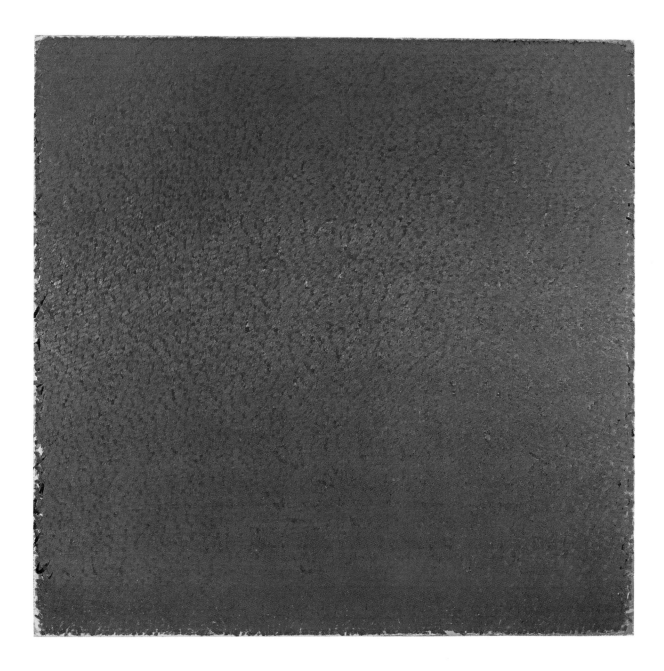

Pl. 16 **Conflicting Thought**, 1983
Oil on canvas, 60 x 60 inches (152 x 152 cm)
Collection of Mari and Peter Shaw

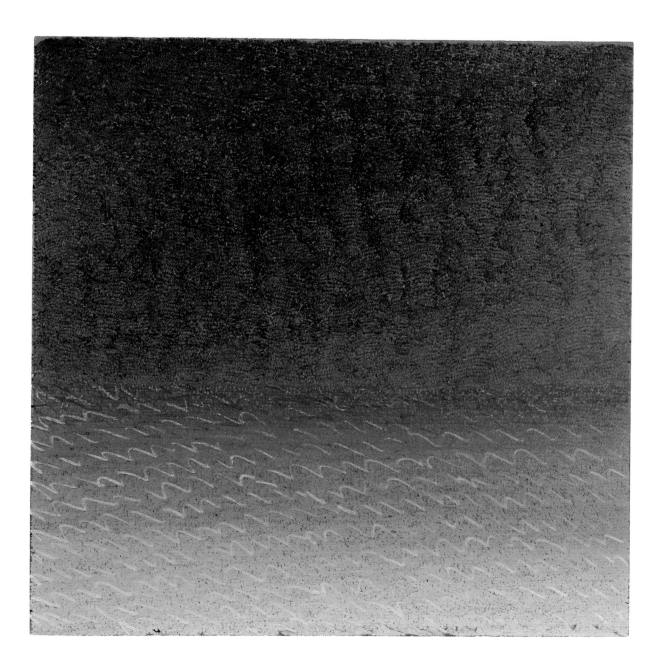

Pl. 17 **Two Elements**, 1984
Oil on canvas, 72 x 72 inches (183 x 183 cm)
Collection Mr. and Mrs. Paul T. Gruenberg

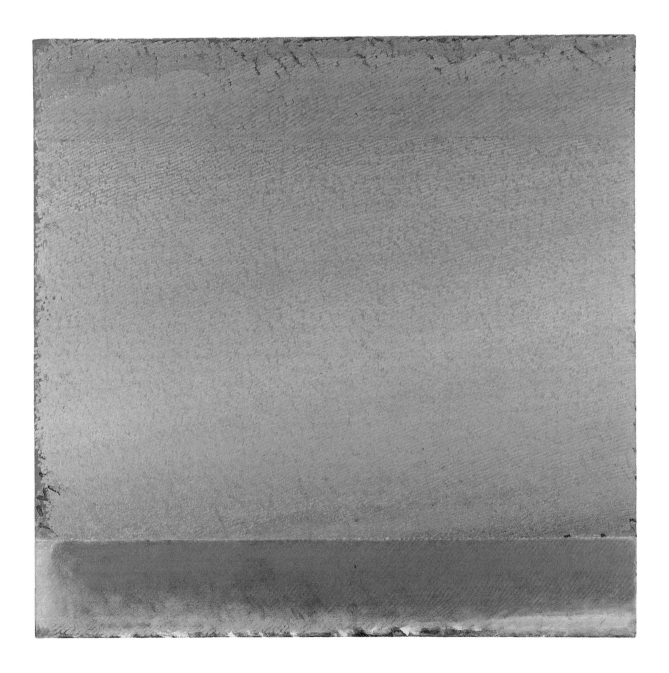

Pl. 18 **Variation on Equation**, 1986–87
Oil on canvas, 72 x 72 inches (183 x 183 cm)
Collection of Ana and Rodman Thompson

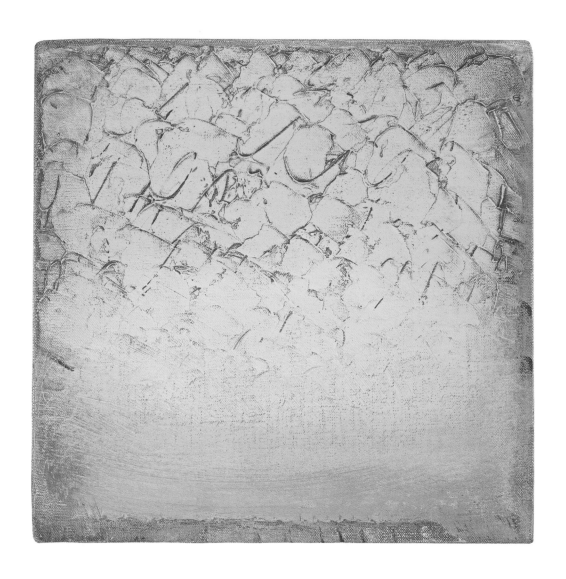

Pl. 19 **Augury 1**, 1984
Oil on canvas, 12 x 12 inches (30 x 30 cm)
Private collection

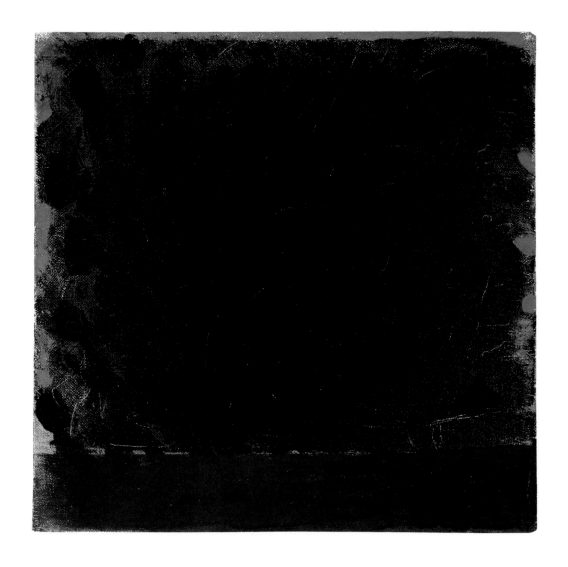

Pl. 20 **Inky Cap**, 1987
Oil on canvas, 12 $^{1}/_{8}$ x 12 $^{1}/_{8}$ inches (31 x 31 cm)
Private collection, courtesy of the Locks Gallery

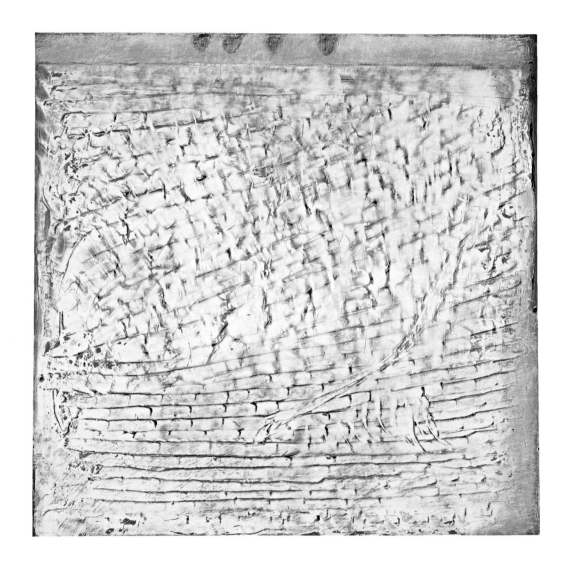

Pl. 21 **Legend**, 1987
Oil on ragboard laminated to pressed board, 12 x 12 inches (30 x 30 cm)
Private collection, courtesy of the Locks Gallery

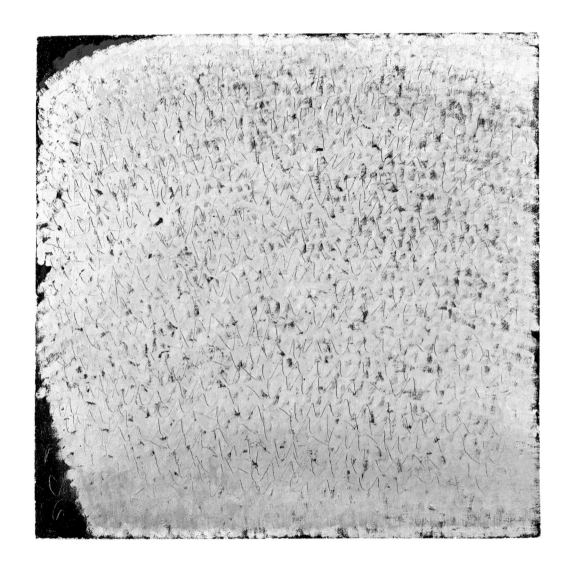

Pl. 22 **Husk**, 1989
Oil on canvas, 16 x 16 inches (41 x 41 cm)
Collection of Mrs. Doris Staffel

Pl. 23 **Field: Twenty Minutes in June**, 1990
Oil on canvas, 66 x 66 inches (168 x 168 cm)
Collection of Mr. and Mrs. Berton E. Korman

Pl. 24 **Caernarvon 2**, 1986–87
Oil on canvas, diptych, 60 x 120 inches (152 x 305 cm)
Collection of Daniel W. Dietrich II

Pl. 25 **Field: Language 9**, 1991
Oil on canvas, 72 x 72 inches (183 x 183 cm)
The Bohen Foundation

Pl. 26 **Field: Language 10**, 1991
Oil on canvas, 72 x 72 inches (183 x 183 cm)
Collection of Jane and Leonard Korman

Pl. 27 **Back and Forth**, 1992
Oil on canvas, 60 x 60 inches (152 x 152 cm)
Private collection, courtesy of the Locks Gallery

Pl. 28 **Untitled 5**, 1993
Oil on canvas, diptych, 72 1/4 x 153 1/2 inches (184 x 390 cm)
Collection of Daniel W. Dietrich II

Pl. 29 **Homage to J. F. Kensett**, 1988
Oil on ragboard laminated to pressed board, 16 x 16 inches (41 x 41 cm)
Collection of Helen W. Drutt English

Pl. 30 **Field: Crossover**, 1990
Oil on ragboard laminated to pressed board, diptych, 15 x 30 inches (38 x 76 cm)
Collection of Daniel W. Dietrich II

Pl. 31 **Untitled**, 1992
Oil on canvas, 16 x 16 inches (41 x 41 cm)
Private collection, courtesy of the Locks Gallery

Pl. 32 **Untitled**, 1993
Oil on canvas, 15 x 15 inches (38 x 38 cm)
Collection of Mr. and Mrs. Jonathan Solomon

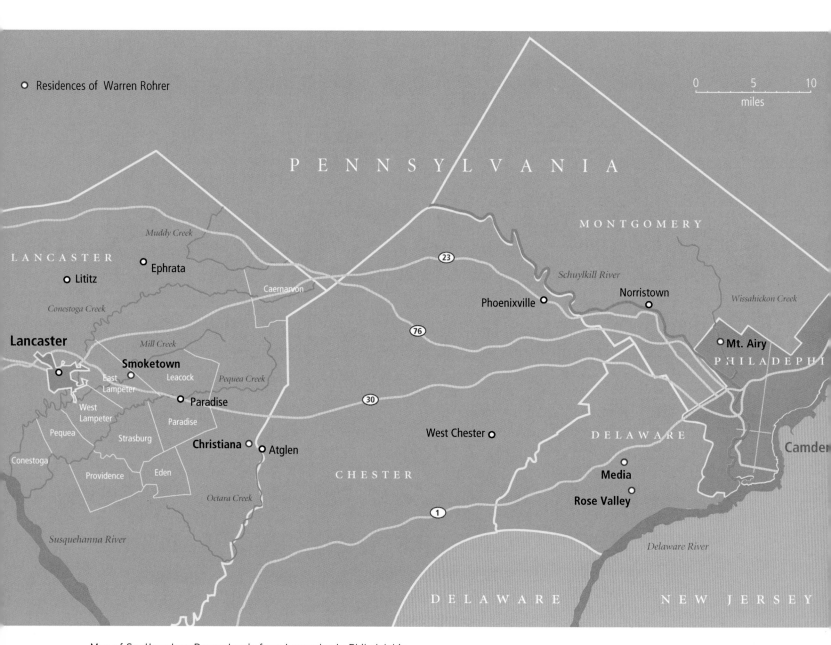

O Residences of Warren Rohrer

0 5 10
miles

PENNSYLVANIA

MONTGOMERY

Muddy Creek

LANCASTER

● Ephrata

● Lititz

Caernarvon

23

Schuylkill River

Norristown ●

Wissahickon Creek

Phoenixville ●

Conestoga Creek

Lancaster

Mill Creek

76

Smoketown

East
Lampeter

Leacock

Pequea Creek

● **Mt. Airy**

PHILADELPHIA

West
Lampeter

O **Paradise**

Paradise

Pequea

Strasburg

30

Conestoga

Providence

Eden

Christiana O

O Atglen

West Chester O

DELAWARE

Camden

Octara Creek

CHESTER

O **Media**

O **Rose Valley**

Susquehanna River

1

Delaware River

DELAWARE

NEW JERSEY

Map of Southeastern Pennsylvania from Lancaster to Philadelphia

Chronology

IVA GUEORGUIEVA

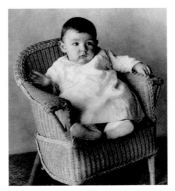

Warren Rohrer, 1927.

Rohrer's parents, Israel D. and Edna Eby Rohrer, October 17, 1923. Wedding photograph by Killian Studio, Lancaster, Pennsylvania.

Paternal grandparents, Daniel Rohrer and Lydia Denlinger Rohrer, 1898. Photograph by Lease Studio, Lancaster, Pennsylvania.

1927
Warren E. Rohrer is born on December 4 in Smoketown, Pennsylvania, near Lancaster. An older brother, Israel, Jr., born June 13, 1926, died the same day. On January 8, 1930, Raymond E. is born, followed by Harold E. on October 4, 1931. Ruth is born on July 18, 1934, but dies the next day. A sister, Verna E., is born April 7, 1939. His parents, Israel D. Rohrer and Edna Eby Rohrer, are poultry farmers. The Rohrer family had lived in Lancaster County as part of a Mennonite community since c. 1730 and the Eby family, since c. 1715.

1933
Rohrer attends West Lampeter Elementary School, a secular school, until seventh grade, where he first demonstrates an interest in drawing. As a fourth grader, he contracts rheumatic fever and is confined to bed. He draws a great deal.

1935
Rohrer's brother Raymond leaves

home to attend the Pennsylvania School for the Deaf in Center City Philadelphia. (Rohrer's paternal grandparents were also deaf.)

1938
Rohrer attends Locust Grove Mennonite School, at Smoketown, graduating in 1941.

1942
He enters Lancaster Mennonite High School, formerly called Yates School, a boys' school east of Lancaster.

1945
Graduates from high school and enters Eastern Mennonite College, Harrisonburg, Virginia. Most of his classes are on the subject of religion (Old Testament history, personal evangelism, teachings of Christ, the Christian family, Mennonite history; other courses include Greek, public speaking, biology, and geology). In his second year he takes courses in painting, composition, design, and crafts.

1946
During the summer he travels to Poland with the United Nations Relief and Rehabilitation Act and Brethren Relief Service to restock cattle herds decimated during World War II. Makes some drawings, but mostly maps.

1947
During the summer he is sent to Kentucky as an itinerant preacher. A member of the school choir, he participates in gospel groups organized by the school.

1948
On November 25 he marries a fellow student at Eastern Mennonite College, Martha Jane Turner, daughter of Mr. and Mrs. C. C. Turner of Broadway, Virginia. He takes a leave of absence from Eastern Mennonite College and the couple returns to live in Smoketown, where he teaches grades seven through ten at West Fallowfield, a Mennonite school in Atglen, Pennsylvania.

1949
The couple returns to Harrisonburg, Virginia, where Rohrer continues his studies at Eastern Mennonite College. In the fall of 1949 he simultaneously enrolls at Madison College (now James Madison University), where he can pursue his study of art education and art, including classes in design, drawing, and painting.

Begins student teaching in art and English at Harrisonburg High School, Harrisonburg, Virginia.

1950
In June graduaes from Eastern Mennonite College with a B.A. in Bible studies.

In the summer takes more classes at Madison in art education, educational psychology, and English literature.

1951
In June receives B.S. in art education from Madison College and

61

Warren Rohrer with his mother, c. 1928.

Warren, Raymond, and Harold Rohrer, 1937.

Warren Rohrer in a dormitory at Eastern Mennonite College, Harrisonburg, Virginia, c. 1945.

teaching certification from the Commonwealth of Virginia, enabling him to teach English, history, and art in high school as well as sixth and seventh grades. Decides he will not enter the seminary, despite his family's expectations.

On September 15 his mother dies. Shortly thereafter his father moves out of the house in which he was raised, and Rohrer's brother Harold moves in to take over responsibility for the family farm. All of Rohrer's drawings from his early years are destroyed. He begins teaching art, history, and English at Montevideo High School in Penn Laird, Virginia, and continues until 1953.

1952
In March Rohrer enters Pennsylvania State University to obtain a Master's degree in art education. On April 24 his first son, Jon Warren Rohrer, is born. In the summer he studies painting with Hobson Pittman, a member of the faculty of the Pennsylvania

Academy of the Fine Arts in Philadelphia, who also ran the summer program at Penn State. A renowned artist and teacher, Pittman began the summer program at Penn State in 1931. Each session ended with a student show juried by professional curators and artists, which was held at the Mineral Industries Gallery.

On November 27 his father, Israel Rohrer, marries Lydia Weaver.

1953
In July Rohrer becomes a fine arts major. He studies at Penn State with Pittman every summer through 1955. During the summer session at Penn State, Gordon Washburn, director of the Carnegie Institute in Pittsburgh, visits Penn State and judges the annual student painting exhibition, awarding Warren Rohrer second prize.

In the fall he moves with his family to Glenwood Avenue in Rose Valley in the Philadelphia area so he can

study at the Pennsylvania Academy of the Fine Arts in the evenings. Rohrer visits Hobson Pittman at his Bryn Mawr home for monthly critiques of his work and continues to do so for the next three years.

To support his family, Rohrer teaches art at Springfield High School, Delaware County, Pennsylvania, and continues teaching there until 1957, also teaching adult classes.

On November 18 a second son, Dean Michael Rohrer, is born.

1954
In January he enrolls in classes two nights per week at the Pennsylvania Academy of the Fine Arts, studying life drawing with Francis Speight, Walter Stuempfig, and, occasionally, younger faculty members Jim Leuders and Ben Kamihara. He is officially enrolled at the Pennsylvania Academy of the Fine Arts through the spring of 1954 and continues to take classes there occasionally until 1955. During the sum-

mer he studies with Hobson Pittman at Penn State and also takes a course on the history of nineteenth-century American art, covering architecture and painting. He writes a research paper on Albert Pinkham Ryder.

In November he receives a letter from Gordon Washburn, director of the Carnegie Institute, Pittsburgh, requesting that he submit slides of his work to be considered for inclusion in the American Section of the 1955 Pittsburgh International Exhibition. Washburn says he has kept Rohrer's work in mind since first seeing it at State College in 1953.

1955
Rohrer's painting *Under the Bridge* is included in the American Section of the Pittsburgh International Exhibition of Contemporary Painting at the Carnegie Institute (October 13–December 18).

During the academic year he begins taking art history courses at the

Warren Rohrer and the staff of *Weathervane* newspaper at Eastern Mennonite College, c. 1946.

Martha Jane Turner and Warren Rohrer, choral group, Eastern Mennonite College, 1946.

Rohrer family (Israel, Edna, Warren, Raymond, Harold, and Verna), c. 1946. Photograph by Lang and York Studio, Lancaster, Pennsylvania.

University of Pennsylvania Graduate School; he studies Impressionist painting and Early Netherlandish painting, but he does not pursue a degree.

On weekends, former colleagues from Penn State and the Pennsylvania Academy of the Fine Arts, Daniel Miller and Hilbert Sabin, visit Rohrer, and the three paint out-of-doors together.

1957

He is hired to be Hobson Pittman's teaching assistant at Friends' Central School in Overbrook, Pennsylvania. When Pittman resigns as director of art at the school in 1957 Rohrer is offered the position but turns it down.

1958

John Canaday, Chief of the Division of Education at the Philadelphia Museum of Art, hires him to teach life drawing and still life painting on Thursdays. During the summer he teaches landscape classes, taking students to sites along the Schuylkill River and in Manayunk. He teaches at the Museum until 1972. The Rohrers move to Crum Creek Road in Media.

1959

In January Hobson Pittman hires him as a visiting instructor in the summer painting program at Penn State University. The Rohrer family lives at Penn State for the summer, renting out their home on Crum Creek Road.

In the fall he returns to teaching painting at the Philadelphia Museum of Art and at the Wayne Art Center, Wayne, Pennsylvania.

1960

One-person exhibition at the Robert Carlen Gallery, Philadelphia (April 8–29). A reviewer in the *Philadelphia Inquirer* (April 17, 1960) writes: "Warren Rohrer's canvases are a combination of romanticism and expressionism." Dorothy Grafly, art critic for the *Philadelphia Bulletin*, reports to Rohrer in a letter that Robert Carlen has described him as "an interesting young abstractionist" (Dorothy Grafly to Warren Rohrer, March 26, 1960, Warren Rohrer Archives, Philadelphia).

John Burrows, a former colleague at Friends Central School, invites the Rohrer family to come to Nova Scotia in the summer, where Burrows directs the Putney School Summer Program. The family camps off the Gulf of St. Lawrence, and Rohrer makes drawings and paints on Masonite, working in a crudely constructed studio open on one side. He reads Vincent van Gogh's *Letters to Theo*, which strongly influences his desire to live in the country. He makes about a hundred large drawings with hand-made quill pens, recalling the reed pen drawings of Rembrandt and Van Gogh. He paints the portrait *John Burrows with a Flute*, the first of a group of portraits he makes in 1960–61. He reads the mystic philosopher Jakob Böehme.

He applies for a John Simon Guggenheim Memorial Foundation grant, hoping to study and paint in the Netherlands during 1960–61 and to visit European museums. In the application he mentions his interest in religious art and in doing experimental work in the field of graphic arts.

1961

In the summer, the Rohrer family moves to a nineteenth-century farmhouse in Christiana, Pennsylvania, not far from his birthplace. The artist builds a studio within the barn adjacent to the house and works there for the next twenty-three years.

As he is settling in to the new environment, he paints portraits of his children and members of the community. Professor of history of art at Eastern Mennonite College, Dr. Irvin B. Horst, contacts him about a commission to create a portrait in

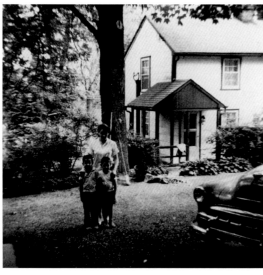

Warren Rohrer, Nova Scotia, summer 1960. Photograph by Charles Turner.

Warren Rohrer exhibition, Delaware Art Museum, 1964.

Jane Rohrer, Jon Rohrer, and Dean Rohrer, Crum Creek Road, Media, Pennsylvania, 1958. Photograph by Warren Rohrer.

woodcut or etching of Menno Simons, founder of the Mennonite religion, to celebrate the 400th anniversary of Simons's death. Horst cautions "If it is to sell to our people it will have to be sufficiently representational to be appreciated." Rohrer accepts this paid commission, and to this day the image is still disseminated to Mennonite congregations.

1962
Teaches painting and criticism classes at Delaware Art Museum, continuing until 1968.

1963
First one-person exhibition at the Makler Gallery, Philadelphia, the most important gallery in the city presenting modern art, including the work of Milton Avery, Alexander Calder, David Smith, the Cobra Painters, and Mark Rothko (December 6–28). Rohrer is one of a small group of artists from the Philadelphia area who exhibit at the Makler Gallery, and his association

with the gallery will continue until 1971.

1964
Exhibits at the Delaware Art Museum.

1965
One-person exhibition at the Makler Gallery, Philadelphia (December 1–24).

1967
In the fall he joins the faculty of Philadelphia College of Art (now the University of the Arts) part-time. Until 1984, when he moves to Mount Airy, he commutes from Christiana to teach in Center City Philadelphia.

Son Jon Rohrer enrolls at Phillips Academy, Andover, Massachusetts.

Exhibition at the Makler Gallery, Philadelphia (December 8–30).

1968
Teaches painting and criticism classes at the Wayne Art Center, Wayne, Pennsylvania; the Westchester

Art Association, Westchester, Pennsylvania, and the Community Art Center, Wallingford, Pennsylvania, continuing until 1974.

The Pennsylvania Academy of the Fine Arts purchases his painting *Pasture Scape*, 1968.

1969
Begins working on shaped paintings made of cut plywood.

One-person exhibition at the Makler Gallery, Philadelphia (December 5–31).

1970
Purchases a truck to use as an easel to support his large canvases while he paints in the landscape.

His son Dean Rohrer enrolls at Phillips Academy, Andover, Massachusetts.

1971
Views *Abstract Design in American Quilts* at the Whitney Museum of

American Art, New York (July 1–September 12). Shortly thereafter he and his wife Jane begin collecting quilts.

On October 30 he sends an ironic letter to the curatorial staff at the Whitney Museum of American Art, New York, proposing inclusion in their painting annual of a work titled "W. R. Isn't Hanging In The Whitney," which he calls "a work of documentation of a fifteen year process."

In the fall he is an artist-in-residence and faculty representative of the Pennsylvania Academy of the Fine Arts at the Delaware Water Gap in a pilot program, Artists for Environment, which was organized by Joel Levy.

Visited by Sam Musser, a Lancaster lawyer, who proposes sponsoring a trip for Warren and his family to live and paint in Corfu, Greece.

Works as a part-time teacher in the evenings at the Pennsylvania Academy of the Fine Arts.

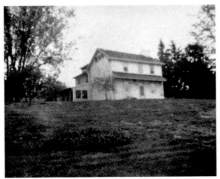

Home of Warren and Jane Rohrer, Christiana, c. 1978. Photograph by Warren Rohrer.

Warren Rohrer, *Portrait of Menno Simons* (founder of the Mennonite religion), 1960. Woodcut, 25 x 19 inches (63 x 48 cm). Commissioned by Eastern Mennonite College.

Warren Rohrer's studio, Christiana, Pennsylvania, c. 1968.

Jon Rohrer graduates from Phillips Academy in June.

One-person exhibition at the Makler Gallery, Philadelphia, *Warren Rohrer: Paintings from the Farm, The Gap (Delaware Water), and Some Shapes* (December 3–31).

1972
Stops teaching at the Philadelphia Museum of Art for a year in order to focus on his painting.

Travels for seven weeks in Greece, Italy, France, and the Netherlands. He and Jane fly to Rome, travel to Florence and Arezzo, and then on to Athens. From April 4 to May 1 they stay in Corfu, Greece, where he paints. They travel to Paris and Amsterdam. He is especially impressed by the work of Rembrandt and Piero della Francesca. He sees the Mark Rothko exhibition at the Musée National d'Art Moderne, Paris (March 23–May 8), and the Barnett

Newman exhibition at the Stedelijk Museum in Amsterdam (March 30–May 22).

Paintings made in Corfu and those made immediately upon his return are exhibited at 113 North Lime Street in Lancaster (October 29–November 18).

Jon Rohrer marries Prilla Higano on July 22.

1973
Views a retrospective exhibition of Agnes Martin's work at the Institute of Contemporary Art, Philadelphia.

Attends a presentation by Agnes Martin at the Philadelphia College of Art.

Views *American Pieced Quilts* at the Smithsonian Institution, Washington, D.C. (October 14–January 8).

1974
First one-person exhibition at the

Marian Locks Gallery, Philadelphia (February 1–26). In a review of the show in the *Philadelphia Bulletin* in February, Nessa Forman writes: "what Rohrer is after in his high-keyed color canvases is models of the landscape system. Think of a field of alfalfa being cut like some giant quilt, whose patterns meet at cross angles left by the backward glide and forward slide of the cutting edge."

Travels with Jane to London and visits museums as well as Stonehenge, from February 21 to March 4.

Purchases a house on 438 Fulton Street, Philadelphia. Spends part of the week in Christiana and part in Philadelphia until he purchases Violet Oakley's former studio at 627 St. George's Road, Mount Airy, in 1983.

Begins teaching full-time at the Philadelphia College of Art (now the University of the Arts). Stops

his other teaching.
Included in the exhibition *Made in Philadelphia 2* at the Institute of Contemporary Art (October 25–December 14).

1975
Susan Heinneman reviews Rohrer's work in an *Artforum* article in January.

Becomes co-chair with Harry Soviak of the painting department of the Philadelphia College of Art but resigns the following year in order to conserve his energy for painting.

At the National Gallery of Art in Washington, D.C., sees the *Exhibition of Archeological Finds of the People's Republic of China* (December 13–March 30).

1976
One-person exhibition at Lamagna Gallery, New York (February 28–March 23). In March, Patricia Stewart writes in *Arts Magazine*: "The landscape is constructed, as is

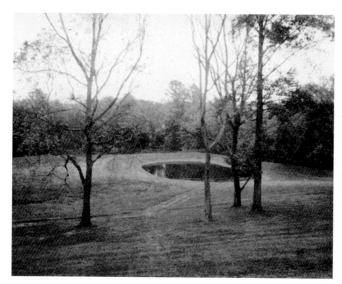

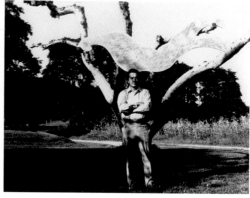

Pond at Christiana, c. 1968.
Photograph by Warren Rohrer.

Warren Rohrer with *Rooster Shape*, 1971.

his meditative painterly style, out of a system of mutual responses. The work doesn't represent or symbolize landscape. Rather, it is a patient 'verification' (his own word, reminiscent of Stieglitz's Equivalents) of relationships perceived in nature and expressed in painting."

Agnes Martin speaks to Warren Rohrer's painting class at Philadelphia College of Art on May 4, and the two visit the Philadelphia Museum of Art exhibition *Philadelphia: Three Centuries of American Art,* which includes Rohrer's 1973 painting *Corn: Stubble* (April 11–October 10).

One-person exhibition at the Marian Locks Gallery, Philadelphia (May 28–June 26).

Jane and Warren Rohrer lend seven quilts from their personal collection to the exhibition *Made in Pennsylvania: A Selection of Amish Quilts (Amish Quilts That Could Have Been Contemporary Paintings),* organized

by Suzanne Delehanty at the Institute of Contemporary Art, Philadelphia (June 16–August 18).

Exhibits at the Institute of Contemporary Art, Philadelphia, in *The Philadelphia Houston Exchange* (October 8–November 17), which includes twenty-three artists from Philadelphia and Houston. The show traveled to Houston after closing in Philadelphia.

Becomes a member of the Commonwealth of Pennsylvania Council for the Arts, appointed through 1979.

1977
Participates in a group exhibition at the Susan Caldwell Gallery, New York (June 8–July 1).

Rohrer is invited to be an artist in residence at Emma Lake Artist's Workshop in Saskatchewan, Canada. He and Jane drive to Canada, and, on the way, visit museums in Pittsburgh, Cleveland,

Chicago, Minneapolis, and Kansas City. They also stop in North Dakota to visit his sister, Verna Beachey.

1978
Tony Arzt, of Adfilm Communications, Inc., New York, makes the film *Warren Rohrer: Artist and the Land* for the U.S. International Communications Agency.

One-person exhibition, at the Marian Locks Gallery, Philadelphia (February 6–26).

Writes an introduction for the exhibition *Pennsylvania Quilts: One Hundred Years, 1830–1930,* organized by Helen Williams Drutt for the Moore College of Art, Philadelphia (November 17–December 15).

Rohrer is artist-in-residence at The Fabric Workshop, Philadelphia. During a check-up for the flu in December Warren Rohrer is diagnosed with leukemia.

1980
One-person exhibition at the Marian Locks Gallery, Philadelphia (February 29–March 26).

1981
Receives the Governor's Award for Excellence in the Arts in Pennsylvania.

Visits museums in San Francisco, Los Angeles, and San Diego.

Awarded a grant from the Pennsylvania Council on the Arts; takes a sabbatical to paint.

Receives an Artist's Fellowship from the National Endowment for the Arts.

1982
One-person exhibition at the Morris Gallery of the Pennsylvania Academy of the Fine Arts (March 5–April 18).

1983
On May 7 signs an agreement to purchase 627 St. George's Road, the former studio of Violet Oakley.

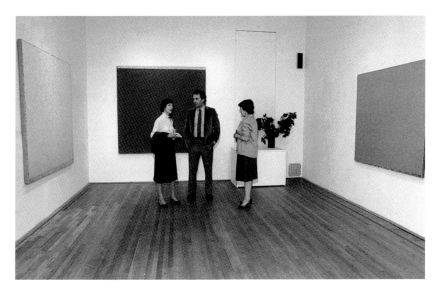

Jane Rohrer, Warren Rohrer, and Charlotte Phelps at Rohrer's exhibition opening at CDS Gallery, New York, September, 1983.

Home and studio of Warren Rohrer, 627 St. George's Road, Mount Airy, 1980. Former studio of Violet Oakley. Courtesy Philadelphia City Archives.

Birth of granddaughter Willa Taylor Rohrer to Jon and Prilla Rohrer on September 13.

One-person exhibition at CDS Gallery, New York (September 15–October 8).

The Metropolitan Museum of Art, New York, purchases *Different Situation 1*, 1983.

Participates in the Demuth symposium, Trinity Lutheran Parish Church, Lancaster, on October 30.

Stephen Levine's article "Warren Rohrer's Fields," a review of the artist's exhibition at CDS Gallery, appears in *Arts Magazine* in December. Levine writes: "Laid bare of extraneous surface structure, like so many fields for sowing, sites for archeological excavation, or psyches for probing, Rohrer's paintings invite the beholder's engagement in the dual process of uncovering and reconstructing."

1984
The Rohrers sell the Christiana farm in April and in June move to 627 St. George's Road on the edge of Fairmount Park, only a fifteen-minute drive from Center City Philadelphia. While construction is under way in the downstairs of the house, Rohrer stretches canvases in a space at the Woodmere Art Museum in the Chestnut Hill section of Philadelphia. He returns to Lancaster County one day a week to paint and draw.

Receives the Governor's Award for Excellence in the Arts.

Honored with the Alumni of the Year Award from Eastern Mennonite College.

1986
One-person exhibition at CDS Gallery, New York (February 6–March 1).

Dean Rohrer marries Clair Warmerdam on May 24.

1987
Begins regular visits to a field in Caernarvon, Lancaster County, where he takes photographs and draws. He continues this activity until 1993.

First of several visits to Scripps Clinic in La Jolla, California, for medical treatment.

One-person exhibition at the Marian Locks Gallery, Philadelphia (May 6–30).

1988
Terminates his contract with CDS Gallery, New York.

Commissioned to create a lithograph commemorating the twenty-fifth anniversary of the Institute of Contemporary Art, Philadelphia. The resulting five-color lithographic print, titled *Bark and Marks*, makes use of tree-bark rubbings as well as marks made by the artist's hands. The lithograph was produced with Tim Sheesley, Corridor Press, and completed in May 1988.

First interview with Marina Pacini of the Archives of American Art, on March 9.

Death of his father, Israel Rohrer, on September 28.

1989
Presents a talk on Hobson Pittman at the Woodmere Art Gallery in conjunction with the exhibitions *Works by Hobson Pittman and Hobson Pittman, The Teacher.*

Visits an exhibition of Asian ceramics at the Metropolitan Museum of Art, New York.

One-person exhibition at the Marian Locks Gallery, Philadelphia (May 2–31).

1990
A retrospective of Rohrer's work from 1973 to 1989 is held at Millersville University, Millersville, Pennsylvania, organized by John Markowitz (September 30–October 30).

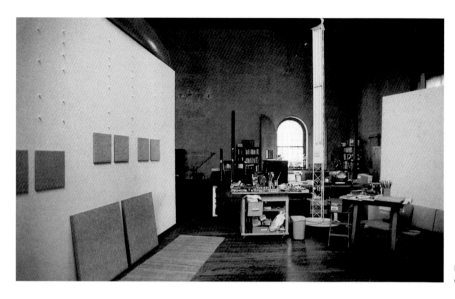

Rohrer's studio,
627 St. George's Road, 1995.

Visits Scripps Clinic, La Jolla, California, for treatment. Rohrer takes photographs of sunsets, desert landscapes, the ocean, and goes to museums in the area.

1991
One-person exhibition of *Field: Language* paintings is held at the Locks Gallery, Philadelphia (September 24–October 26).

Lectures at People's Place Gallery, Intercourse, Pennsylvania, on the relationship of his painting to his Mennonite origins, on November 8 and 9.

1992
Birth of his granddaughter Janie Rohrer to Clair and Dean Rohrer on February 25. Another granddaughter, Greta, will be born to Clair and Dean on April 8, 2000.

Retires from teaching as professor of painting, University of the Arts, Philadelphia.

1993
Travels to Vero Beach, Florida, from February 25 to March 10.

One-person exhibition at the Locks Gallery, Philadelphia (October 13– November 10).

Invited by Lois Snavely Frey, a clinical social worker, to participate in a discussion group "Mennonite Roots Pursuing Creativity."

1994
Travels to Vero Beach, Florida, from February 24 to March 15.

1995
Warren Rohrer dies on February 21.

A memorial service is held at the Community Mennonite Church, Lancaster, on March 4.

A memorial service is held at the Locks Gallery, Philadelphia, on March 5.

Selected Statements by Warren Rohrer

Journal entry, September 7, 1958

Paint—if it gets in one's way—then we have to stop smearing around—greater and greater simplicity, this to show the essence of meaning—life.

Journal entry, August 7, 1960

The evening, last, re-asks the questions, "What is the painter?" and "wherefore comes the painting?" The sun moves from the pink, to the unbelievable yellow and deep with the glow of a hundred beats, then hangs in a sea of green yellow fog, transparent as any in the brook pool. Finally the bubbles of magenta red dance in and out of sun shape to flatten, to fatten, to wheel it into an unmovable path—like a circular saw buzzing into a deep nothing.

Letter to Bayard and Frances Storey, March 27, 1967

The "grid" idea has not been carried out *yet*—vacations, snow flurries, etc.

Letter to Bayard and Frances Storey, January 24, 1972

Jane and I are in for some travel. A group of business and professional people from Lancaster, headed by my lawyer Sam Musser, has raised a sum to send us to Corfu for the month of April. The Mussers had been there last fall with a chartered group and decided I ought to have an opportunity to paint olive and fig orchards in bloom. Right nice of them we think. . . . We leave March 23 from Philadelphia to Boston to Rome to Florence to Rome to Athens to Corfu—three days four nights in Florence and three in Rome and two in Athens. On return trip we stop for a couple days each in Paris and Amsterdam. Return May 7.

Letter to Bayard and Frances Storey, February 16, 1972

The . . . announcement of my proposed leave-of-absence from teaching was not quite intended. I did want to mention to you that unless there was a great (bad) flood, earthquake or calamity I was going to give my work *the push* next year. I'm tired of not doing what I can do and I've become "recovered" from the "nothing" happening in regard to the shapes (undeveloped) in my last show at Makler and feel that the possibility of plastic shapes for Charlotte (joke) and metal shapes, pierced and sprayed for the orchard, and wooden shapes [see fig. 10] to *sit* around doing their thing—plus conceptual truck and real landscape. Being ready for development for successful ends is where it's all at. . . . So no teaching next year.

Sketchbook note, 1970s

What's the sense of nature/
and what connection to painting/
shape isn't important/
movement is/
most important is color/
what does situation say about color/
when./

Warren Rohrer, 1980. Photograph by John J. Carlano.

Rohrer's studio, 627 St. George's Road, 1995.

Rohrer's studio,
627 St. George's Road, 1995.

Letter to Bayard and Frances Storey, 1977

I like your comment on the lack of display of method or technique. This is very important to me, and know that part (big part) of my concern is to show how regular, how everyday, how commonplace existence is, but how spectacular. Not fireworks but like a falling leaf.

Typed statement, March 1980

About ten years ago, acting on the realization that landscape (and more inclusively, nature) was more than what I looked at, I redirected my attention to painting processes, which, interestingly enough, often paralleled the agricultural processes I had known all my life. I built all-over surfaces by layering brushwork in which color was often extracted from seasonal information.

Since then I've spoken and written about my "stroke," specific and at the same time neutral, as my way of being in the work. These recurring strokes, famous for about a fifteenth of a second, are absorbed in the process and can be read in

the paintings as the carriers of the color changes, referring to prior color stance and foretelling the inevitable course of the painting.

Sketchbook entry, July 31, 1981

The obliteration of structure in order to produce surface—surface preempts structure.

Sketchbook entry, December 28, 1981

Paintings are:
—realized regrets
—summations (plans to go) on going somewhere and not necessarily getting there
—or realized plans for going somewhere and not necessarily getting there. . . .

Regarding regrets—it is with some joy that I recognize this state of affairs.

Sketchbook entry, May 7, 1983

Signed agreement for 627 St. Georges Road.

Soon "from the farm" references will stop. We're in an interim. We're still at the farm but knowing we've decided to leave. The painting attitude is affected.

Rohrer's studio, 627 St. George's Road, 1995.

Rohrer's studio, 627 St. George's Road, 1995.

Sketchbook entry, May 27, 1989

In view is a 36-inch bloody red over an almost black/or removed from black first layer except for a covered white ground area/rounded up from lower edge about 2¾ inches. The red forms a tough, thick surface with scratches and tooled gouges an attempt to get through the tough skin to the underlayer the red starts at upper left where remnant of underneath darkness defines the corner/itself and the beginning image of red (the idea for the beginning red shape came from the edge of Caernarvon field [Lancaster County]). . . .

I'd like to keep the red but feel it has to be richer. Will the ongoing strokes support the red or is it time for a new way to keep/change the red—thin washes—after the initial

Caernarvon, October 1987. Photograph by Warren Rohrer.

red—go back to blackish—with green I don't want to go to far way from the present. The bottom is like an upturned flattened tube.

Interview with Marina Pacini, June 1, 1989
The use of the limited palette was very important because it kept me from focusing on a lot of colors. It made an issue of dealing with limitation. Limitation in itself is a significant element in dealing with painting. . . .

It was at that same time [around the 1955 Pittsburgh International] I started to be aware of this idea of accident or the happening that you

Caernarvon, July 1988. Photograph by Warren Rohrer.

didn't plan. In other words, it's as though you were tapping into some source that was beyond the known and it was totally part of the unknown. So you were involved with a life rhythm or a painting rhythm or even a kind of language that made you uncomfortable because you found yourself participating in something that was not familiar. . . .

I remember what it was like to walk from the barn where my studio was to the house at dinner. It would often be just about the time the sun was going down and it would be a certain kind of light was going across the top of the grasses. That was like "here's the moment." . . . I learned to think about the landscape as being a message bearer. It gave me a lot of information, something about the nature of forces greater than I am. I was fortunate to be a participant in these forces, to observe them, to be an activator. I think in a sense I think my painting is simply about that.

Caernarvon with snow, December 1989. Photograph by Warren Rohrer.

Letter to Daniel W. and Jennie Dietrich II, March 11, 1993
While driving through "my country" yesterday I was interested that it seemed so numbing and brutal. I always am aware of the feelings I have about the Lancaster Co. landscape, that while it at times is very beautiful it sometimes gnaws from a different perspective—both being real responses.

Caernarvon, October 1991. Photograph by Warren Rohrer.

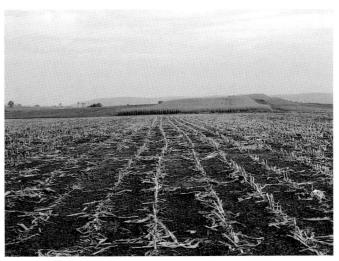

Caernarvon, October 1987. Photograph by Warren Rohrer.

Solo Exhibitions

1960

Robert Carlen Gallery, Philadelphia, *Paintings and Drawings by Warren Rohrer*, April 8–29

Warehouse Gallery, Arden, Delaware, *Paintings and Drawings by Warren Rohrer*, May 1–21

Madison College, Harrisonburg, Virginia, May

1963

Wilcox Gallery, Swarthmore College, Swarthmore, Pennsylvania, *Paintings by Warren Rohrer*, March 16–31

Makler Gallery, Philadelphia, December 6–28

1964

Lincoln Gallery, West Chester, Pennsylvania, *Paintings by Warren Rohrer*, April 3–23

Delaware Art Museum, Faculty Exhibition

1965

Makler Gallery, Philadelphia, *Warren Rohrer*, December 1–24

1967

Goethean Hall Gallery, Franklin and Marshall College, Lancaster, Pennsylvania, February 12–March 10

Makler Gallery, Philadelphia, *Warren Rohrer*, December 8–30

1968

Community Center, Wallingford, Pennsylvania, March 31–April 30

1969

Barr-Hurst Bookstore Gallery, Lancaster, Pennsylvania, April 15–May 15

Makler Gallery, Philadelphia, *Warren Rohrer*, December 5–31

1971

Makler Gallery, Philadelphia, *Warren Rohrer: Paintings from the Farm, The Gap (Delaware Water) and Some Shapes*, December 3–31

1972

113 North Lime Street, Lancaster, Pennsylvania, *Corfu Paintings and Drawings*, October 29–November 18

1974

Marian Locks Gallery, Philadelphia, *Morning Fogs Trees and Leaves: Recent Paintings,* February 1–26

1976

Lamagna Gallery, New York, *Warren Rohrer: Paintings,* February 28–March 23

Marian Locks Gallery, Philadelphia, *Warren Rohrer: Recent Paintings,* May 28–June 26

1978

Marian Locks Gallery, Philadelphia, *Warren Rohrer,* February 6–26

1980

Marian Locks Gallery, Philadelphia, *Warren Rohrer,* February 29–March 26

1982

Morris Gallery, Pennsylvania Academy of the Fine Arts, Philadelphia, *Warren Rohrer: Passage; an Exhibition of Paintings,* March 5–April 18

1983

CDS Gallery, New York, *Warren Rohrer,* September 15–October 8

1986

CDS Gallery, New York, *Warren Rohrer,* February 6–March 1

Eastern Mennonite College, Harrisonburg, Virginia, October 5–30

1987

Marian Locks Gallery, Philadelphia, *Warren Rohrer,* May 6–30

1989

Marian Locks Gallery, Philadelphia, *Warren Rohrer,* May 2–31

1990

Ganser Gallery, Millersville University, Millersville, Pennsylvania, *Warren Rohrer: Selected Paintings, 1973-1989,* September 30–October 30

1991

Locks Gallery, Philadelphia, *Warren Rohrer,* September 24–October 26

1993

Locks Gallery, Philadelphia, *Warren Rohrer: New Paintings,* October 13–November 10

1995

Locks Gallery, Philadelphia, *Warren Rohrer: Works on Paper,* November 3–December 16

1996

Locks Gallery, Philadelphia, *Warren Rohrer: The Breakthrough Years,* October 4–November 9

1998

Locks Gallery, Philadelphia, *Warren Rohrer: Variations on the Square (1972–1975),* May 1–30

2000

Locks Gallery, Philadelphia, *Warren Rohrer: Field Language, Drawings and Paintings,* March 1–April 8

2002

Locks Gallery, Philadelphia, *Warren Rohrer, Paintings 1972–1975,* November 1–December 14

Selected Group Exhibitions

1953
Pennsylvania State University, University Park, *Annual Student Painting Exhibition*

1954
Friends Central School, Overbrook, Pennsylvania, *Twenty-third Annual Invitation Exhibition*, May

Pennsylvania State University, University Park, *Annual Student Painting Exhibition*

1955
Philadelphia Museum of Art, *First Philadelphia Art Festival Exhibition*, February 26–March 27

Friend's Central School, Overbrook, Pennsylvania, *Twenty-fourth Annual Invitation Exhibition*, May

Department of Fine Arts, Carnegie Institute, Pittsburgh, *The 1955 Pittsburgh International Exhibition of Contemporary Painting*, October 13–December 18

1956
Gettysburg College, Gettysburg, Pennsylvania, two-person exhibition with Dan Miller

Pennsylvania Academy of the Fine Arts, Philadelphia, *Fellowship of the Pennsylvania Academy of the Fine Arts Annual Exhibition*, March 9–April 8

Friends' Central School, Overbrook, Pennsylvania, *Twenty-fifth Annual Invitation Exhibition*, May

Wilmington Society of the Fine Arts, Delaware Art Center, Wilmington, *Forty-Third Annual Delaware Show*, November 16–December 20

1957
Cheltenham Art Center, Cheltenham, Pennsylvania, *New Talent Show*, January 13–February 3

1958
Pennsylvania Academy of the Fine Arts, Philadelphia, *Fellowship of the Pennsylvania Academy of the Fine Arts Annual Exhibition of Painting and Sculpture*, March 7–April 6

Galerie Philadelphie, Paris, *Paintings by Americans, Including Philadelphians*, May

Wilmington Society of the Fine Arts, Delaware Art Center, Wilmington, *Forty-fifth Annual Delaware Show: Oils and Sculpture*, October 9–November 9

Fidelity-Philadelphia Trust Company, Philadelphia, *Annual Exhibition of the Regional Council of Community Art Centers*, November 16–21

1959
Pennsylvania Academy of the Fine Arts / Philadelphia Water Color Club, *The One Hundred and Fifty-fourth Annual Exhibition*, January 25–March 1

Pennsylvania Academy of the Fine Arts, Philadelphia, *Fellowship of the Pennsylvania Academy of the Fine Arts Annual Exhibition of Painting and Sculpture*, March 14–April 12

Cheltenham Arts Center, Cheltenham, Pennsylvania, *Twelfth Annual Award Show*, April 5–May 3

Woodmere Art Gallery, Philadelphia, *Nineteenth Annual Exhibition of Oil Paintings and Sculpture*, April 19–May 10

Wilmington Society of the Fine Arts, Delaware Art Center, Wilmington, *Forty-sixth Annual Delaware Show: Oils and Sculpture*, November 13–December 28

Pennsylvania State University, University Park, *Annual Faculty Exhibition*

Columbia Museum of Art, Columbia, South Carolina, *Second Columbia Painting Biennial*

1960
Pennsylvania Academy of the Fine Arts, Philadelphia, *Fellowship of the Pennsylvania Academy of the Fine Arts Annual Exhibition of Painting and Sculpture*, March 12–April 10

Wilmington Society of the Fine Arts, Delaware Art Center, Wilmington, *Forty-seventh Annual Delaware Art Show*, November 11–December 23

1961
Woodmere Art Gallery, Philadelphia, *An Invited Exhibition by Louis Eaton, Tom Gaughan, Mitzi Melnicoff, Henry Peacock, Warren Rohrer and Erna Stenzler: Young Artists of Philadelphia*, February 12–March 5

1962
Philadelphia Museum of Art, *Third Philadelphia Arts Festival*, Summer

Wilmington Society of the Fine Arts, Delaware Art Center, Wilmington, *Paintings, Sculpture, Drawings and Prints Owned by Mrs. Josiah Marvel*, June 23–August 12

Birmingham Museum of Art, Birmingham, Alabama, *Color*, November 15, 1962–January 1, 1963

1964
Pennsylvania Academy of the Fine Arts, Philadelphia, *Fellowship of the Pennsylvania Academy of the Fine Arts Annual Exhibition of Painting and Sculpture*, March 14–April 12

Wilmington Society of the Fine Arts, Delaware Art Center, Wilmington, *Fiftieth Annual Delaware Show, Local: Oils and Sculpture*, March 20–April 19

Wilmington Society of the Fine Arts, Delaware Art Center, Wilmington, *Carol Chandler, Julio Acuna, Warren Rohrer and Ben Solowey*, October 14–November 8

1965
Wilmington Society of the Fine Arts, Delaware Art Center, Wilmington, *Fifty-first Annual Delaware Show, Regional: Oils and Sculpture*, March 19–April 18

Philadelphia Art Alliance, *Early Art Alliance Exhibitors*, November 8–December 5

Philadelphia Museum of Art, *Instructors' Exhibition*, December

1966
Pennsylvania Academy of the Fine Arts, Philadelphia, *Fellowship of the Pennsylvania Academy of the Fine Arts Annual Exhibition of Painting and Sculpture*, March 24–April 24

Wilmington Society of the Fine Arts, Delaware Art Center, Wilmington, *Invited Regional Exhibition*, May 13–June 12

1967
Philadelphia Art Alliance, *Self-Portraits by Philadelphia Artists*, October 2–29

Drexel Building, Philadelphia, *Philadelphia Arts Festival*

1968

Pennsylvania Academy of the Fine Arts, Philadelphia, *One Hundred and Sixty-third Annual Exhibition*, January 19–March 3

Woodmere Art Gallery, Philadelphia, *An Invited Group Exhibition by Painters John Bekavac, Stephanie Pacek, David Pease, Jane Piper, Walter Reinsel, Warren Rohrer and Harvey Silverman and Sculptors Steffi Greenbaum and Joseph J. Greenberg, Jr.*, February 11–March 3

Pennsylvania Academy of the Fine Arts, Philadelphia, *Fellowship of the Pennsylvania Academy of the Fine Arts Annual Exhibition of Painting and Sculpture*, March 16–April 14

Community Arts Center, Wallingford, Pennsylvania, March 31–April 26

1969

Student Center, University of Delaware, Newark, *Eighth Regional Art Exhibition*, January 12–February 9

Pennsylvania Academy of the Fine Arts, Philadelphia, *Fellowship of the Pennsylvania Academy of the Fine Arts Annual Exhibition of Painting and Sculpture*, March 22–April 20

1970

Municipal Arts Gallery, Museum of the Philadelphia Civic Center, *Fellowship of the Pennsylvania Academy of the Fine Arts Annual Exhibition of Painting and Sculpture*, March 21–April 26

Haas Gallery, Bloomsburg State College, Bloomsburg, Pennsylvania, *Landscape Painters in Pennsylvania*, April 14–30

Philadelphia Museum of Art, *Second Eastern Central Regional Drawing Exhibition of the Drawing Society*, June 30–September 1

1971

Woodmere Art Gallery, Philadelphia, *Fellowship of the Pennsylvania Academy of the Fine Arts Annual Exhibition of Painting and Sculpture*, February 7–28

Downtown Gallery, Delaware Art Museum, Wilmington, *Philadelphia Painters: Larry Day, Sidney Goodman, Allen Koss, Elizabeth Osborne, Warren Rohrer*, March 25–April 20

Peale Galleries, Pennsylvania Academy of the Fine Arts, Philadelphia, *Nine Members of the Academy Faculty*, May 20–July 31

1972

Pennsylvania Academy of the Fine Arts, Philadelphia, *Fellowship of the Pennsylvania Academy of the Fine Arts Annual Exhibition of Painting and Sculpture*, January 29–February 27

1973

Joslyn Art Museum, Omaha, Nebraska, and Sheldon Memorial Art Gallery, Lincoln, Nebraska, *A Sense of Place: The Artist and the American Land*, September 23–October 28

1974

Pennsylvania Academy of the Fine Arts, Philadelphia, *Fellowship of the Pennsylvania Academy of the Fine Arts Annual Exhibition*, March 2–31

Pennsylvania State University Museum, University Park, *The Philadelphia Scene*, August 4–September 1

Institute of Contemporary Art, University of Pennsylvania, Philadelphia, *Made in Philadelphia 2*, October 25–December 14

1975

Goshen College Art Gallery, Goshen, Indiana, *Mennonite Artists: Contemporary*, February 2–March 16

Corcoran Gallery of Art, Washington, D.C., *The Delaware Water Gap*, July 11–August 31

Moore College of Art, Philadelphia, *PMA at MCA: An Exhibition of Works by Contemporary Philadelphia Artists, Selected from the Collection of the Philadelphia Museum of Art*, October 16–November 21

1976

Philadelphia Museum of Art, *Philadelphia: Three Centuries of American Art*, April 11–October 10

Philadelphia College of Art, *Artist's Sketchbooks 1: Philadelphia*, September 8–October 6

Institute of Contemporary Art, University of Pennsylvania, Philadelphia, *The Philadelphia Houston Exchange*, October 8–November 17. Also shown at Contemporary Arts Museum, Houston, Spring 1977.

1977

Susan Caldwell Gallery, New York, *Four Painters: Arlene Bayer, Jerry Clapsaddle, Samia Halaby, Warren Rohrer*, June 8–July 1

1978

U.S. Federal Courthouse, Philadelphia, *Elemental Painting: Fifteen Philadelphia Artists*, April 28–June 11

Philadelphia College of Art, *Point*, November 18–December 15

Pennsylvania Academy of the Fine Arts, Philadelphia, *Contemporary Drawings: Philadelphia I*, September 15–November 26

1979

Philadelphia Museum of Art and Pennsylvania Academy of the Fine Arts, Philadelphia, *Contemporary Drawings: Philadelphia II*, March 24–May 20

1980

Governor's Residence, Harrisburg, Pennsylvania, and Institute of Contemporary Art, University of Pennsylvania, Philadelphia, *Made in Philadelphia III*, June 2–26

1981

Cheltenham Art Center, Cheltenham, Pennsylvania, *Series*, January 11–February 8

Third Street Gallery, Philadelphia, *Art Salon '81*, April 23–May 17

Allentown Art Museum, Allentown, Pennsylvania, *Broad Spectrum: Artists Who Teach at the Philadelphia College of Art*, March 8–April 19. Also shown at the University Art Gallery, University of Pittsburgh, May 8–June 26; and William Penn Memorial Museum, Harrisburg, Pennsylvania, August 15–November 22.

1982

Woodmere Art Gallery, Philadelphia, *Pennsylvania Artistry: A Celebration*, May 16–June 27

CDS Gallery, New York, *Invitational Group Exhibition*, September 11–October 8

Allentown Art Museum, Allentown, Pennsylvania, *Gifts to the Museum: A Decade of Collecting*, October 3, 1982–January 2, 1983

1984

Woodmere Art Museum, Philadelphia, *Painter's Choice: New Talent*, September 16–October 28

Marion Art, Lancaster, Pennsylvania, *Philadelphia Elementalism, Part I: Warren Rohrer Paintings and Bruce Pollock Helixes and Blocks*, October 7–27

Paul Cava Gallery, Philadelphia, *Group Show: Louisa Chase, Francesco Clemente, Lydia Hunn, Rebecca Johnson, Marcus Leatherdale, Nino Longobardi, Robert Mapplethorpe, Jan Morgen, Warren Rohrer, Susan Rothenberg, Richard Rydell, Peter Sasgen, Joel Peter Witkin, and Others*, November 16–December 22

1985

Sordoni Art Gallery, Wilkes College, Wilkes-Barre, Pennsylvania, *The New Expressive Landscape*, April 19–May 19

1986

CDS Gallery, New York, *Further Exposure*, June 12–July 25

Philadelphia Museum of Art, *Philadelphia Collects: Art Since 1940*, September 28–November 30

Governor's Residence, Harrisburg, Pennsylvania, September–October

1988

Delaware Center for Contemporary Arts, Wilmington, Delaware, *Qualities of Paint*, September 16–October 28

Pennsylvania Academy of the Fine Arts, Philadelphia, *Searching Out the Best: A Tribute to the Morris Gallery of the Pennsylvania Academy of the Fine Arts*

1989

Locks Gallery, Philadelphia, *Looking Back: The Seventies at Marian Locks,* December 12, 1989–January 30, 1990

1990

Laurie W. and Irwin J. Borowsky Gallery at the Gershman Y, Philadelphia, *Limited Editions from the Borowsky Center for Publication Arts and the Philadelphia College of Art and Design Printmaking Workshop, The University of the Arts,* November 28, 1990–January 27, 1991

Philadelphia Museum of Art, *Contemporary Philadelphia Artists: A Juried Exhibition,* April 22–July 8

1991

Locks Gallery, Philadelphia, *Directions: Paintings–Sculpture–Prints,* January 10–February 23

Institute of Contemporary Art, University of Pennsylvania, Philadelphia, *Philadelphia Art Now: Artists Choose Artists,* January 19–March 3

Fabric Workshop, Philadelphia, *New Dimensions: Nine Artists Design Scarves,* November 26, 1991–January 4, 1992

Larry Becker Gallery, Philadelphia, *Works on Paper,* December 1991–January 1992

1992

Canton Art Institute, Canton, Ohio, *Traditions and Transitions: Amish and Mennonite Expression in Visual Art,* April 10–July 5

Levy Gallery, Moore College of Art, Philadelphia, *In the Realm of the Monochrome: Paintings and Works on Paper by Philadelphia Artists,* September 4–October 11

Gallery 400, University of Illinois, Chicago, *On Condition: Painting Between Abstraction and Representation,* October 5–31

1993

Locks Gallery, Philadelphia, *Group Painting Exhibition,* January 5–February 6

1994

City Without Walls, Newark, New Jersey, *Sign Language,* January 6–February 11

1998

Institute of Contemporary Art, University of Pennsylvania, Philadelphia, *From Warhol to Mapplethorpe: Three Decades of Art at ICA,* September 12–November 1

2000

Woodmere Art Museum, Philadelphia, *Celebrating Philadelphia's Artistic Legacy: Selections from the Woodmere Art Museum Permanent Collection,* September 10, 2000–January 21, 2001

Selected Bibliography

Archives

Archives of American Art, Smithsonian Institution, Washington, D.C., Oral History Interview with Warren Rohrer by Marina Pacini, March 9, 15, May 25, June 1, 1989

Archives of the Department of Modern and Contemporary Art, Philadelphia Museum of Art

Warren Rohrer Archives, Philadelphia

Books and Monographs

Broad Spectrum: Artists Who Teach at the Philadelphia College of Art. Exh. cat. Allentown, Pennsylvania: Allentown Art Museum, 1981.

Contemporary Philadelphia Artists: A Juried Exhibition. Exh. cat. Philadelphia: Philadelphia Museum of Art, 1990.

The Delaware Water Gap. Exh. cat. Washington, D.C.: Corcoran Gallery of Art in collaboration with Artists for the Environment, 1975.

Goodyear, Frank, and Ann Percy. Contemporary Drawings: Philadelphia 1. Exh. cat. Philadelphia: Pennsylvania Academy of the Fine Arts, 1978.

Gussow, Allan. A Sense of Place: The Artist and the American Land. Exh. cat. 2 volumes. Omaha, Nebraska: Joslyn Art Museum, 1972.

Le Clair, Charles. Color in Contemporary Painting: Integrating Practice and Theory. New York: Watson-Guptill Publications, 1991.

Made in Philadelphia 2. Exh. cat. Philadelphia: Institute of Contemporary Art, 1974.

Philadelphia: Three Centuries of American Art. Exh. cat. Philadelphia: Philadelphia Museum of Art, 1976.

The Philadelphia Houston Exchange. Exh. cat. Philadelphia: Institute of Contemporary Art, 1976.

Rohrer, Warren. "My Experience with Quilts (A Bias)." In Pennsylvania Quilts: One Hundred Years, 1830–1930. Exh. cat. Philadelphia: Moore College of Art and Design, 1978.

Rosenthal, Mark, and Ann Percy. Philadelphia Collects: Art Since 1940. Exh. cat. Philadelphia: Philadelphia Museum of Art, 1986.

Schubert, Janet M. "Warren Rohrer: Landscape as Experience." Master's thesis, University of the Arts, Philadelphia, March 1989.

Searching Out the Best: A Tribute to the Morris Gallery of the Pennsylvania Academy of the Fine Arts. Philadelphia: Pennsylvania Academy of the Fine Arts, 1988.

Warren Rohrer. Exh. cat. Philadelphia: Locks Gallery, 1989.

Warren Rohrer: New Paintings. Exh. cat. Philadelphia: Locks Gallery, 1993.

Warren Rohrer: Selected Paintings, 1973–1989. Exh. cat. Millersville: Millersville University of Pennsylvania, 1990.

Warren Rohrer: The Breakthrough Years. Exh. cat. Philadelphia: Locks Gallery, 1996.

Warren Rohrer: Morning Fogs Trees and Leaves. Exh. cat. Philadelphia: Locks Gallery, 2002.

Articles

"Art and Environment." Lancaster New Era, November 26, 1971, p. 14.

"Art Comes Out of Painting." Lancaster New Era, July 16, 1971, p. 16.

"Artist Aids Lawyer Clinch Case for Island's Charm." Lancaster Sunday News, October 29, 1972, p. 58.

"Artist Sells Painting to Met." Lancaster New Era, October 26, 1983, p. 3.

Beyer, Rita. "Colors, Layers Help Define Rohrer Abstract Paintings." Chestnut Hill Local, May 25, 1989, p. 41.

—. "Contemporary Artists View the 1970s." Review of Looking Back: The Seventies at Marian Locks, Philadelphia, December 12, 1989–January 30, 1990. Chestnut Hill Local, January 11, 1990, p. 32.

—. "New Works by Rohrer at Locks Gallery." Review of Warren Rohrer: New Paintings, Locks Gallery, Philadelphia, October 13–November 10. Chestnut Hill Local, October 28, 1993, p. 37.

Boasberg, Leonard W. "Documenting Roots of American Art: Marina Pacini Is a Bit of a Detective as She Puts Together the Puzzle That Is Philadelphia's Art History." Philadelphia Inquirer, October 20, 1990, p. C-1.

Brakeman, Mark. "First Third Thursday's a Success!" Review of From Warhol to Mapplethorpe, Three Decades of Art at ICA, Institute of Contemporary Art, Philadelphia, September 12–November 1. Philadelphia Weekly Press, September 24–30, 1998, p. 8.

Brown, Gerard. "Rohrer Test." Review of Warren Rohrer: Variations on the Square (1972–1975), Locks Gallery, Philadelphia May 1–30. Philadelphia Weekly, April 29, 1998, p. 61.

"Christiana Artist to Exhibit Corfu Paintings." Lancaster New Era, October 12, 1972, p. 4.

"City Gallery to Exhibit Rohrer Art." Lancaster Sunday News, April 13, 1969, p. A-13.

Csaszar, Tom. "Warren Rohrer, Ganser Gallery, Millersville University." Review of Warren Rohrer: Selected Paintings, 1973–1989, Millersville, Pennsylvania, September 30–October 30. New Art Examiner, vol. 18, no. 8 (April 1991), p. 43.

Donohoe, Victoria. "Abstraction, Realism and Nature All Wrapped Up in a Single Artist." Review of Warren Rohrer, Marian Locks Gallery, Philadelphia, February 29–March 26. Philadelphia Inquirer, March 7, 1980, p. 29.

—. "Academy Teachers Show They Also Can Do." Review of Nine Members of the Academy Faculty, Peale Galleries, Pennsylvania Academy of the Fine Arts, Philadelphia, May 20–July 31. Philadelphia Inquirer, July 16, 1971, p. 14.

—. "Cluster Showings: They Work." Review of Art Salon '81, Third Street Gallery, Philadelphia, April 23–May 17. Philadelphia Inquirer, May 1, 1981, p. E-37.

—. "Diffused Light, Space and Color Create Harmony." Review of Warren Rohrer, Marian Locks Gallery, Philadelphia, May 6–30. Philadelphia Inquirer, May 16, 1987, p. 4-C.

——. "From Abstract Landscape Works to Necklaces Made of Steel Wire." Review of *Warren Rohrer: Passage*, Morris Gallery, Pennsylvania Academy of the Fine Arts, Philadelphia, March 5–April 18. *Philadelphia Inquirer*, April 2, 1982, p. F-38.

——. "Is Abstract Painting Regaining Its Popularity?" *Philadelphia Inquirer*, September 14, 1984, p. E-34.

——. "Where Landscape Meets Abstract." Review of *Warren Rohrer*, Marian Locks Gallery, Philadelphia, May 2–31. *Philadelphia Inquirer*, May 6, 1989, p. D-4.

"Fifty Artists to Inaugurate ICA's New Building." *Philadelphia Inquirer*, June 27, 1990, p. F-4.

"Five Thousand Seven Hundred Dollars in State Grants Go to Playwright, Artist." *Lancaster New Era*, December 4, 1980, p. 4.

Flood, Richard. "Art and Photography: The Philadelphia Houston Exchange." Review of *The Philadelphia Houston Exchange*, Institute of Contemporary Art, Philadelphia, October 8–November 17, 1976. *Philadelphia Arts Exchange*, January–February 1977, pp. 31–32.

Forman, Nessa. "The Sunday Painters." *Philadelphia Bulletin*, July 11, 1971, sec. 2, p. 8.

——. "The System of Landscape." *Philadelphia Bulletin*, February 10, 1974, p. AB-8.

Frank, Peter. "New York Reviews: Warren Rohrer." Review of *Warren Rohrer: Paintings*, Lamagna Gallery, New York, February 28–March 23. *ARTnews*, vol. 75, no. 5 (May 1976), p. 134.

"Gallery Highlights." Review of *Warren Rohrer: Paintings*, Marian Locks Gallery, Philadelphia, May 28–June 26. *Philadelphia Inquirer*, June 20, 1976, p. H-11.

Grafly, Dorothy. "Makler Gallery." Review of *Warren Rohrer*, Makler Gallery, Philadelphia, December 3–31. *Philadelphia Bulletin*, December 28, 1969, p. VD-9.

Heinneman, Susan. "Reviews." Review of *Made in Philadelphia 2*, Institute of Contemporary Art, Philadelphia, October 26–December 14, 1974. *Artforum*, vol. 13, no. 9 (January 1975), pp. 65–68.

Henry, Gerritt. "New York Reviews: Warren Rohrer." Review of *Warren Rohrer*, CDS Gallery, New York, September 15–October 8. *ARTnews*, vol. 82, no. 9 (November 1983), p. 201.

"Judges Named." *Lancaster Intelligencer Journal*, November 9, 1978, p. 44.

Kaye, Ellen. "She Made the House Her Own: Out Went the Silk Drapes, in Came the Comfortable Chairs." *Philadelphia Inquirer*, January 10, 1988, p. 32.

Kesral, Deni, "Concrete Abstract." Review of *Warren Rohrer: New Paintings*, Locks Gallery, Philadelphia, October 13–November 10. *Philadelphia Welcomat*, October 20, 1993, p. 64.

Knowles, Laura. "Nostalgia through the Artist's Eye in Demuth Exhibit." *Lancaster Intelligencer Journal*, December 5, 1997, p. 9.

Leon, Dennis. "Rohrer Show." Review of *Paintings and Drawings by Warren Rohrer*, Robert Carlen Gallery, Philadelphia, April 8–29. *Philadelphia Inquirer*, April 17, 1960, p. 7.

Levine, Steven Z. "Warren Rohrer's *Fields*." *Arts Magazine*, vol. 56 (December 1983), pp. 74–75.

——. "The Scar of Language: Rohrer's Filial Fields." In *Warren Rohrer*. Exh. Cat. Philadelphia: Locks Gallery, 1991.

Lewis, Mary Tompkins. "Warren Rohrer: Marian Locks." Review of *Warren Rohrer: The Breakthrough Years*, Locks Gallery, Philadelphia, October 4–November 9. *ARTnews*, vol. 96, no. 2 (February 1997), pp. 120–21.

"Local Artist's Exhibit Opens." *Lancaster New Era*, May 27, 1971, p. 44.

"M. Locks Gallery." Review of Warren Rohrer, *Morning Fogs Trees and Leaves: Recent Paintings*, Marian Locks Gallery, Philadelphia, February 1–26. *Philadelphia Inquirer*, February 17, 1974, p. I-11.

McClain, Matthew. "Warren Rohrer." Review of *Warren Rohrer: Passage*, Morris Gallery, Pennsylvania Academy of the Fine Arts, Philadelphia, March 5–April 18. *New Art Examiner*, vol. 9, no. 6 (April 1982), p. 17.

McFadden, Sarah. "Report from Philadelphia." *Art in America*, vol. 67, no. 3 (May–June 1979), pp. 21–31.

"New Group Show at Avondale Gallery Is Homage to Rohrer." Review of *Summer in Wallingford*, Avondale Gallery, Rose Valley, Pennsylvania, July 18–31, 1971. *Philadelphia Inquirer*, July 18, 1971, sec. 7, p. 8.

Osterhout, David. "Area Artist Chosen for Film to Be Shown around World." *Lancaster New Era*, October 25, 1978, p. 54.

"People's Place Hosts 'Art '91' Nov. 8 & 9." *Lancaster Intelligencer Journal*, October 30, 1991, p. B-3.

Poirer, Maurice. "New York Reviews: Warren Rohrer." Review of *Warren Rohrer*, CDS Gallery, New York, February 6–March 1. *ARTnews*, vol. 85, no. 5 (May 1986), pp. 133–34.

Posnock, Susan Thea. "Exhibit Explores the Art of Symbols." Review of *Sign Language*, City Without Walls, Newark, New Jersey, January 6–February 11. *Asbury Park Press*, March 9, 1994, p. E5.

Rankin, Mary. "Quick Sketch: Warren Rohrer and Neil Welliver." *Art Matters*, May 1988, p. 4.

Rice, Robin. "When Contemporary Was Yesterday." Review of *From Warhol to Mapplethorpe: Three Decades of Art at ICA*, Institute of Contemporary Art, Philadelphia, September 12–November 11. *Philadelphia City Paper*, September 24, 1998, p. 26.

Rickey, Carrie. "The Show of Shows: The Institute of Contemporary Art Celebrates Its Thirty-fifth Year by Reprising Some Stars It Helped Launch." Review of *From Warhol to Mapplethorpe: Three Decades of Art at ICA*, Institute of Contemporary Art, Philadelphia, September 12–November 11. *Philadelphia Inquirer Magazine*, October 18, 1998, pp. 13–14.

"Rohrer Art Chosen for Phila. Show." *Lancaster Sunday News*, October 20, 1974, p. 29.

Russell, Ruth R. "Artist Creating a Studio at Former Oakley Site." *Chestnut Hill Local*, April 12, 1984, p. 37.

Ruth, Jim. "Local Roots Leave Mark on Warren Rohrer's Canvas." *Lancaster Sunday News*, September 23, 1990, p. H-1.

Scott, William P. "At Woodmere, a Testament to a Teacher." *Philadelphia Inquirer*, May 3, 1989, p. D-4.

"Second Judge Named for Art Show." *Lancaster Intelligencer Journal*, May 19, 1970, p. 11.

Seldis, Henry J. "Three Hundred Years of U.S. Creativity." *Los Angeles Times*, April 12, 1976, sec. IV, pp. 1, 5.

Solis-Cohen, Lita. "Robert Carlen, 84, a Dealer in Antiques Here Since 1938." *Philadelphia Inquirer*, August 22, 1990, p. E-10.

Sozanski, Edward J. "Art." Review of *Works on Paper*, Larry Becker Gallery, Philadelphia, December 1991–January 1992. *Philadelphia Inquirer*, January 3, 1992, p. 8.

——. "Art: Locks Gallery." Review of *Warren Rohrer: The Breakthrough Years*, Locks Gallery, Philadelphia, October 4–November 9. *Philadelphia Inquirer*, November 8, 1996, p. 36.

——. "Art: Locks Gallery." Review of *Warren Rohrer: Works on Paper*, Locks Gallery, Philadelphia, November 3–December 16. *Philadelphia Inquirer*, December 8, 1995, p. W-53.

——. "Art Galleries." Review of *Warren Rohrer: New Paintings*, Locks Gallery, Philadelphia, October 13–November 10. *Philadelphia Inquirer*, November 5, 1993, p. 40.

——. "At Levy, 24 Phila. Artists Explore Monochrome without Monotony." Review of *In the Realm of the Monochrone: Paintings and Works on Paper by Philadelphia Artists*, Levy Gallery, Moore College of Art and Design, Philadelphia, September 4–October 12. *Philadelphia Inquirer*, September 10, 1992, p. C-4.

———. "'Directions' Launches a New Building." Review of *Directions: Paintings–Sculpture–Prints,* Locks Gallery, Philadelphia, January 10–February 23. *Philadelphia Inquirer,* January 18, 1991, p. 34.

———. "Fabric Workshop." Review of *New Dimensions: Nine Artists Design Scarves,* Fabric Workshop, Philadelphia, November 26, 1991–January 4, 1992. *Philadelphia Inquirer,* December 26, 1991, p. D-3.

———. "ICA, at Thirty-five, Looks Back on Its Glory Days." Review of *From Warhol to Mapplethorpe: Three Decades of Art at ICA,* Institute of Contemporary Art, Philadelphia, September 12–November 1. *Philadelphia Inquirer,* September 20, 1998, p. F-11.

———. "Keeping a Legacy Alive to Sustain the Memory of Violet Oakley, a Pioneering Artist Here." *Philadelphia Inquirer,* August 9, 1987, p. D-1.

———. "One Hundred Twenty-nine from Area Picked for 'Art Now' Showing." *Philadelphia Inquirer,* September 23, 1989, p. C-1.

———. "Painting in the New Year with Works from Old Ones." Review of *Looking Back: The Seventies at Marian Locks,* Locks Gallery, Philadelphia, December 12, 1989–January 30, 1990. *Philadelphia Inquirer,* January 11, 1990, p. F-5.

———. "The Art It Takes to Make a Book." *Philadelphia Inquirer,* September 22, 1988, p. C-3.

———. "This Artist Let His Work Talk for Him." *Philadelphia Inquirer,* March 5, 1995, p. K-1.

———. "Warren Rohrer: Marian Locks." Review of *Warren Rohrer,* Locks Gallery, Philadelphia, September 24–October 26, 1991. *ARTnews,* vol. 91, no. 2 (February 1992), p. 138.

———. "Warren Rohrer, Major Figure in Philadelphia's Art World." *Philadelphia Inquirer,* February 25, 1995, p. D-8.

———. "Woodmere Struts Its Stuff." Review of *Celebrating Artistic Legacy: Selections from the Woodmere Art Museum Permanent Collection,* Woodmere Art Museum, Philadelphia, October. *Philadelphia Inquirer,* October 15, 2000, p. I-4.

Stewart, Patricia. "Warren Rohrer." Review of *Warren Rohrer: Paintings,* Lamagna Gallery, New York, February 28–March 23. *Arts Magazine,* vol. 50, no. 7 (March 1976), p. 5.

Taylor, Sam. "One-Man Phila. Show Features Local Art." *Lancaster New Era,* February 22, 1982, p. 32.

"Warren Rohrer, County Native, Painter, Art Prof." *Lancaster New Era,* February 23, 1995, p. B-3.

"Warren Rohrer, Lancaster Painter, at the Academy of Fine Art." Review of *Warren Rohrer: Passage,* Morris Gallery, Pennsylvania Academy of the Fine Arts, Philadelphia, March 5–April 18. *Philadelphia City Paper,* April 1982, p. 23.

"Warren Rohrer Art on Display at MU." *Lancaster New Era,* September 27, 1990, p. 3.

"Warren Rohrer to Be Judge for Seventh Open Art Show." *Lancaster New Era,* September 20, 1965, p. 30.

"Warren Rohrer's Work Next at Goethean Hall." *Lancaster Sunday News,* February 5, 1967, p. 25.

Witmer, Douglas, "Listening to the Land." *Kairos,* vol. 2, no. 1 (Spring–Summer 1997), pp. 1, 4–6.

Yocum, Naomi. "Portrait of an Artist as a Complex Man." *Lancaster New Era,* September 20, 1970, p. 15.

Zimmer, William. "Signs That Carry a Message and Others That Are Abstract." Review of *Sign Language,* City Without Walls, Newark, New Jersey, January 6–February 11. *New York Times* (New Jersey edition), February 27, 1994, p. 10.

Film and Video

Warren Rohrer: Artist and the Land. Produced and directed by Tony Arzt. New York: U.S. International Communications Agency, 1978.

Warren Rohrer. Videotape produced for the exhibition *The Philadelphia Houston Exchange.* Philadelphia: Institute of Contemporary Art, 1976.

Acknowledgments

The talent, energy, and commitment of many individuals made this exhibition and catalogue possible. First and foremost I thank Jane Rohrer, who has been actively involved in the project from the beginning and generously gave of her time, knowledge, and spirit over several years of preparation. It has been a great pleasure and an honor to work with the entire Rohrer family, and for their participation and friendship I also extend warmest thanks to Jon Rohrer, Dean Rohrer, Prilla Rohrer, and Clair Rohrer.

I am especially indebted to Daniel W. Dietrich II for his incalculable devotion to this project and for graciously sharing his responses to Warren Rohrer's paintings as well as his vivid recollections of the artist and the man. Frances Storey also made a very special contribution in her conversations with me.

Many other colleagues and former students shared remembrances during conversations and interviews. I am grateful to Stephen Berg, Cynthia Dorsey Brown, Tom Chimes, Hannah Coale, Julie and Neil Courtney, Stuart Elster, David Hall, Carlo Lamagna, Dr. Paul Todd Makler and Hope Makler, Fred McBrien, Daniel Miller, John Ruth, Sid Sachs, Marc Salz, Doris Staffel, Clara Sujo, and Richard Torchia.

The private lenders who entrusted their precious paintings to us made the exhibition possible. The timely support of The Judith Rothschild Foundation and The Pew Charitable Trusts enabled us to launch the exhibition. Sueyun Locks and the staff of the Locks Gallery, including John Caperton, Doug Schaller, and Noah Young, kindly assisted with locating paintings and shared access to paintings in storage.

For guidance in organizing the exhibition and preparing the catalogue I am indebted to Anne d'Harnoncourt, The George D. Widener Director of the Philadelphia Museum of Art, and to Ann Temkin, The Muriel and Philip Berman Curator of Modern and Contemporary Art. I also extend my thanks to Danielle Rice, Associate Director for Program, for helpful suggestions.

The Publishing Department at the Philadelphia Museum of Art merits high praise for their work. Thank you to Sherry Babbitt, Director of Publishing, and especially to Jane Watkins, Senior Editor, who deftly oversaw the editing of the book, assisted by David Updike, Associate Editor. Richard Bonk expertly managed the production. The beautiful and sensitive design of this book is the work of Andrea Hemmann of GHI Design.

Iva Gueorguieva brought fresh insights and great enthusiasm to this project, and I thank her for excellent contributions to the chronology and bibliography. I also appreciate Jessica Murphy's assistance in tracking down photographs. I thank my colleagues in the Department of Modern and Contemporary Art, particularly extending my gratitude to Michael Taylor, Melissa Kerr, and Shira Rudavsky.

Many other individuals at the Museum contributed to the organization of the exhibition, in particular, Suzanne Wells, who smoothly coordinated the planning for this exhibition, and Irene Taurins and Elie-Anne Chevrier in the Office of the Registrar, who managed shipping and insurance. Suzanne Penn and Joe Mikuliak in the Department of Conservation brought their expertise to examining paintings. Graydon Wood and Lynn Rosenthal contributed new photography to the catalogue, and in Rights and Reproductions, Conna Clark and James Jason Wierzbicki were especially helpful. In the Library, Allen Townsend, Lilah Mittelstadt, Jesse Trbovich, and Josephine Chen assisted with research questions. The installation could not have been realized without Michael McFeat, Martha Masiello, and their colleagues in Packing and Art Handling. Jack Schlechter and Andy Slavinska created the elegant presentation and lighting of the exhibition.